the
watercolor
artist's
flower
handbook

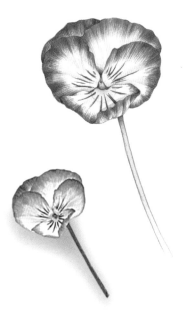

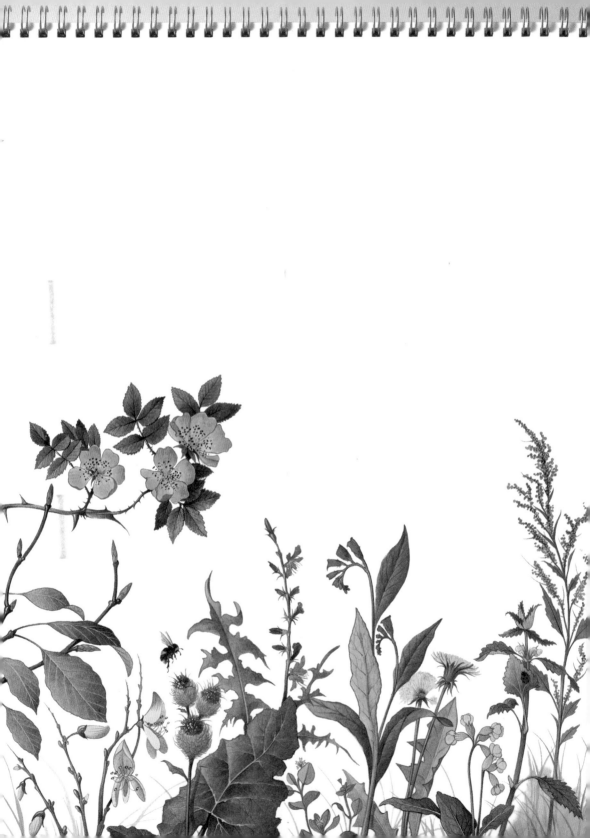

the watercolor artist's flower handbook

Leading floral artists show
how to capture the beauty of flowers

PATRICIA SELIGMAN

WATSON-GUPTILL PUBLICATIONS
NEW YORK

A QUARTO BOOK

First published in New York
by Watson-Guptill Publications,
a division of VNU Business Media, Inc.,
770 Broadway
New York, NY 10003
www.wgpub.com

ISBN: 0-8230-5616-3

QUAR.WASF

Conceived, designed, and
produced by
Quarto Publishing plc
The Old Brewery
6 Blundell Street
London N7 9BH

Project Editor *Liz Pasfield*
Copy Editor *Claire Waite Brown*
Designer *Karin Skånberg*
Photographer *Paul Forrester*
Proofreader *Sue Viccars*
Indexer *Pamela Ellis*

Art Director *Moira Clinch*
Publisher *Piers Spence*

Color separation by Universal Graphic
Pte Ltd., Singapore.
Printed by Midas Printing
International Ltd.
Printed in China

9 8 7 6 5 4 3 2 1

Contents

Introduction 6

Materials 8

Keeping a sketchbook 14

Learning to look 18

Choosing and mixing colors 24

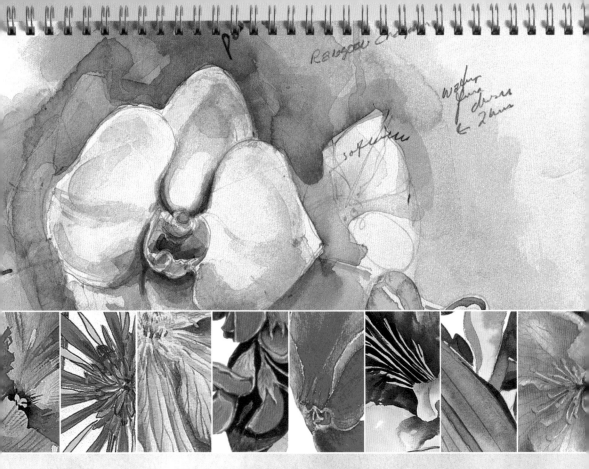

The artists 28

Peggy Macnamara 30

Jane Leycester Paige 40

Marlene Hill Donnelly 54

Sharon Himes 62

Iris Edey 70

Ann Blockley 78

Freda Cox 86

Lizzie Harper 92

Olivia Petrides 104

Carole Andrews 110

Sally Robertson 120

Ann Smith 130

Tracy Hall 136

Index 142

Credits 144

Anyone who has drawn or painted flowers will have discovered how challenging it is to capture their impossible color and simple beauty. A successful flower painting should depict the essence of the flower; its shape, texture, and color; as well as intangible qualities such as freshness and scent, and all on a two-dimensional surface. Many artists have spent time searching for success in capturing these qualities. Some try to pin down the spirit of a flower in formal botanical paintings of exquisite beauty, while others aim to express their ephemeral spirit through more expressionistic line and color.

Introduction
The Sketchbook—A Journey of Exploration and Discovery

Illusive spirit of flowers The results in a sketchbook are often more successful in capturing the delicate nature of flowers than more formal finished paintings.

Yet whatever final approach is favored, most flower painters record their journey of exploration in their sketchbooks. This book looks at the behind-the-scenes work of some of the most successful flower artists through their sketchbooks and, by doing so, hopes to communicate some invaluable inspiration to aspiring flower artists.

THE IMPORTANCE OF SKETCHING
Featuring the sketchbook drawings and paintings of some successful contemporary painters of flowers in watercolor, this book allows you to see the work that has gone into producing flower paintings. Preliminary work in a sketchbook lets artists get to know their subjects—every petal, sepal, and stamen—by drawing and painting flowers over and over again. No two flowers are the same—and in some cases the immediacy and energy of the flower is often more successfully distilled in the fluid marks of the original pencil or watercolor sketch than in the more formal painting that follows.

This book starts with a short, practical section that looks at all aspects of painting flowers in watercolor. There is advice here on the materials that are suited to the subject and some personal tips from our experienced artists. Next the focus turns to the sketchbook itself, comparing different methods of keeping a sketchbook and looking at ways to hone your observational skills. The choices you have to make when you paint— such as how to edit your subject—are also considered. Finally, this introductory section looks at one of the more taxing aspects of watercolor flower painting, the choosing and mixing of colors, and discusses tried-and-tested palettes and useful color mixes.

Generating ideas A sketchbook gives you the opportunity to explore. Rapid visual note-taking often leads to renewed inspiration.

With the practicalities dealt with, we then lead on to the heart of the book, the sketchbook work of thirteen inspired watercolor flower artists. Each artist introduces her work, outlining her vision and offering advice. Sketchbooks are a private form of art, not aimed at a wider public, but, as this book testifies, they can give the greatest pleasure to those allowed the rare privilege of dipping in to look at these investigative flower paintings. By doing so, you will be able to study the wide range of techniques used to record the intricacies of flora and discover how different aims produce different approaches.

As well as being able to marvel at the beauty of these sketchbooks, you will learn from these journeys of exploration, observing how to capture the physical characteristics of a wide range of flowers from all over the world. You will be able to see, too, how flowers can develop from first pencil marks, through the building up of watercolor washes, to the final details. Through this unique book you can learn from the experts how to capture the brilliant colors of flowers and give them life on the page.

Materials

Surrounding yourself with a vast array of artists' materials may give you a certain degree of confidence, but to start drawing and painting flowers in watercolor all you need is paper—a sketchbook would be perfect—a pencil, a few paints, a brush, and some water. These minimal requirements create no problems for the watercolor artist who likes to paint flowers where they grow, rather than arranged in a vase. Simply pack the materials in a small rucksack with a bottle of water and some paper towels and you are ready to travel. You could also include a plastic bag to protect your sketchbook from watery onslaughts and a light tube to protect your precious brushes, without affecting the weight or bulk of your kit.

Pocket sketchbook
A small sketchbook is easy to carry around in your pocket and useful when you spot a flowering weed in a parking lot. A hard cover on your book will protect your work on its travels and will give you something to press down on.

SKETCHBOOKS
A well-bound sketchbook containing good-quality paper is well worth spending money on. Psychologically it will encourage you to produce your best work, and you will find it is both a joy to use and a joy to come back to. Choosing a sketchbook will take a little thought since your choice should be influenced by the flowers you want to explore and how you like to record them.

Choosing a sketchbook size The size of your sketchbook is important. It should not be so big that it is a chore to carry, yet it is a mistake to choose a sketchbook that is too small. For the detail, you might want to draw and paint

Spiral binding Whether in the form of a single page note pad (left) or one that opens as two pages (above), your paper is guaranteed to lie flat while you are working and your watercolor washes will be easier to control.

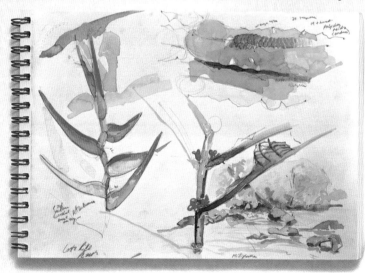

Delicate pen and ink sketches A smooth surface is needed to retain the fragility of the line work.

life-size, so your sketchbook should be at least 10 x 7 inches (254 x 178mm). Jane Leycester Paige (see pages 40–53) likes to paint the wildflowers of Britain *in situ,* which can involve crouching on a mossy bank to study primroses, or sitting out in open chalk downs to paint a wild orchid. A large sketchbook would be cumbersome in her case. Peggy Macnamara (see pages 30–39) loves the exotic flora found in equatorial climates, which are physically much larger than the delicate subjects that Jane seeks out, and therefore requires a larger sketching page. Both artists have more than one sketchbook on the go and choose the size of book to suit the job at hand.

Working in situ *A small portable sketchbook is what's needed for spontaneous flower observations.*

Paper texture and weight It is a good idea to try out various sorts of paper to discover which best suits your style and expectations. You can imagine that Iris Edey (see pages 70–77), with her stunning pen-and-ink studies, does not want a rough-surfaced paper. For detail, particularly for pen and pencil sketches, the paper surface needs to be smooth. However, it should not be too light in weight. Watercolor sketches—particularly ones with flooded washes—need an absorbent surface and a heavier weight to keep the paper from buckling. The slight texture you get from a cold-pressed "not" surface helps to break up the watercolor stroke and is the preferred surface of many of our artists.

Which paper? *Rough paper is textured and absorbent, (great for the loose, washy effects seen in the orchid painting above), hot-pressed is smooth and nonabsorbent, while cold-pressed paper (known as "not") has a certain texture but is smooth enough for detail. For drawing and painting, a good all-rounder would be 140-1b (300-gsm) not.*

Types of paper Paper—whether bound in a sketchbook or in single sheets—can be bought in a variety of thicknesses or weights, and with different surfaces.

The weight of paper is measured in pounds per ream (grams per square meter/gsm). The range is narrower for sketchpads than loose paper, between 72 and 140 lb (150–300gsm). Your approach to flower painting and sketching will help you find a preferred weight; for example, watercolor sketches with heavy washes will require a heavy paper.

WATERCOLOR PAINTS

Translucent washes of watercolor—rich pinks, oranges, and violets—can be combined to mimic the vibrant colors of flowers. Layering these transparent colors will create subtle mixes, with the white of the paper shining through to give them a startling brilliance that comes close to pinning down the flower's essence. But first the practicalities of which watercolor paints to use must be ironed out.

Tubes or pans? Watercolor paints can be bought in tubes or in pans. Tubes travel well and some would say make it easier to keep the paint clean, or at least access clean paint when you need it. Pans set in a box are robust and easy to transport, and many artists prefer them. Clean paint is important for the flower painter, but in the heat of the moment it is easy to take a loaded brush to a pan in a box, thereby dirtying it. Since some of the flower painters' preferred colors can be particularly expensive this can result in wasted paint. However on the less positive side of tubes: it is often stressful finding the color you want in the confusion of tubes in their box; it is easy to squeeze out too much paint and waste

Personal choice The choice between tubes of liquid ready-to-use colors or square pans with dry colors that need mixing with water is a personal one. Both have advantages and disadvantages.

Paintboxes The traditional paintbox allows you to choose your own selection of pans, with the enameled metal lid and mixing tray useful as a premixing surface for your washes. Remember though that the enamel becomes gradually discolored making it more difficult to see the true mix of your colors.

Ceramic palettes These are essential for mixing large quantities of color washes. The palette always cleans back to white and is easy to wipe clean for transportation home.

it; and tubes can come between you and your painting, unlike pans that you can simply cast your eye over to find the illusive rose-petal tint.

You may find that once you have located the tube you need in its box, prized it open because the paint has solidified around the top, and squeezed it out, that the moment has vanished.

Quality Watercolor paints are usually sold in two qualities: artists' and students.' The latter are cheaper, but they contain a smaller proportion of pure pigment in the paint, which means the colors are not as intense. In addition, these paints are often less transparent, more grainy, and are not as reliably lightfast. All these characteristics make the life of the flower painter more difficult, so it is a good idea to save up for the best paints available.

WATERCOLOR FLOWER PAINTER'S KIT
The materials outlined below make up a comprehensive kit, so you won't need everything immediately. Start with the basics and build up your kit where experience suggests you need it—with another type of pencil or a different brush, for example.

Round brushes A flower painting is often completed from start to finish with just one round brush. You should, however, consider buying a few round brushes that will produce between them almost all the brush marks you

Transportation
Light weight plastic home improvement containers for screws and nails have a handy handle, and allow for the categorization of colors into separate drawers.

Artists' advice

Of course you can combine tubes and pans, like Carole Andrews (see pages 110–119). She buys half-pans and installs them in her larger-than-usual paintbox, which takes 48 pans. She uses the pan and refills it with tube paint. Another tip from Carole is to duplicate colors that you use a lot. For example, Carole uses aureolin yellow and transparent yellow for mixing greens, and inevitably the pans get dirty. So, a second pan of each color is kept pristine and used only for glazing, neatly, with a clean brush. Ann Blockley (see pages 78–85) uses pans for sketching but finds she prefers tubes for her finished paintings.

will need. For washes, a large round brush, at least size 12, is a good choice. Also consider sizes 6 and 2, and 00 for fine detail. Kolinsky sable brushes are considered the best, but are also the most expensive. This brush retains its shape and holds a remarkable quantity of paint. However, there are cheaper synthetic alternatives, or sable/synthetic combinations, which are used by many of the artists featured in this book.

Other brushes and useful implements A rigger, which has very fine, long hairs, is useful for minute details, and an angled brush can be good for cutting in around a flower's shape. Explore too, Chinese calligraphy brushes for interesting linear marks. You can also try making painted marks with other, customized implements. For example, you could use the brush end for drawing out paint from a wash, while a piece of thick paper dipped in paint and touched down on the page can suggest a stalk. Your subject will provide you with more ideas.

Pencils for sketching Pencils are not expensive, so you can afford to try out a few different types. Start with a hard 2H, medium HB, and soft 2B. You will also need a good pencil sharpener, or you could try propelling pencils, with HB or 2H leads, that will

Artists' advice

Iris Edey (see pages 70–77) uses a pen and ink to sketch with and finds it forces her to concentrate, since mistakes cannot be erased. Pens also give her control and, of course, do not need sharpening. There are lots to choose from. Iris looks for constancy of flow and she likes to be able to control the width of the line (which can be exaggerated in the scanning process). She has finally opted for fiber-tipped pens and uses Zig Millennium pens in various sizes from 0.05 up.

Brushes and pencils *You do not need a large range especially when traveling. Store brushes upright to keep points in good shape. First buy yourself one good brush, preferably large size (10-12) and get used to working with it before you go out and buy more.*

Studio studies *To save holding the flower specimen in your hand or resting it on a flat surface and thereby distorting the petals you can hold it securely in florists' foam or mini clamps.*

give you uninterrupted sharp leads. Colored pencils are softer than graphite and using them can be a good way to make you loosen up if you are getting too obsessed with detail with a graphite pencil. Try as well the water-soluble ones for another view on color.

Palettes and jars Any clear or white dish can be used as a watercolor palette as long as it carries enough liquid to ensure you do not need to remix in the middle of a wash. Disposable plastic food containers work well, as does the Chinese painter's ceramic "flower" palette, although this is heavy to carry on the go.

 Water must be kept clean, so you will need a jar for mixing and a jar for cleaning. Disposable cups invariably get knocked over, so glass jars are preferable.

Useful extras Paper towels are always useful, whether they are twisted into a point and used to lift off areas, or chase back errant washes, or simply to mop up spills. Cotton swabs are good, too, since they are already pointed and can quickly lift out or soften edges—small sponges can be used in the same way. Masking fluid is not used as much in the sketchbook, but this is a good place to try it out and see how it performs, since it works better on some papers than others. Small flower details that are so hard won can be more easily achieved with the help of this liquid. A low-tack masking tape can be applied to paper to mask off an area, then removed without harming the surface.

Other useful equipment
Pruning shears and a water atomizer are useful as is a magnifying glass for making a close study.

The flower kit As well as the painting essentials, the flower painter will also need a flower kit. This might contain pruning shears, to cut garden flowers so that they last; vases, jugs and bottles to put flowers in; and a water atomizer to keep your flowers sparkling fresh—which is also useful for too-dry washes. A magnifying glass allows you to make a close study of a flower's details and a mirror is always useful for looking at your work objectively.

Artists' advice

Peggy Macnamara (see pages 30–39) is a great fan of the Niji Waterbrush for painting while traveling. The plastic handle holds water, which saves carrying cumbersome bottles, and is available in various sizes.

Petasites japanica

Keeping a sketchbook

There are many reasons for keeping a sketchbook. Probably the most important is that you do just that, keep it. This means that your sketchbook work, eventually spanning years, will always be there for you to refer to. Your sketchbooks will be a fund of information and ideas, and will also plot your progress. Keeping a sketchbook encourages you to work at your art, honing your sketching and painting skills. It will sharpen your powers of observation and help you learn to process information quickly. It is also a good place to try out new techniques, finding the best way to capture nature's imaginative artworks—like the innocence of the primrose or the spiky confidence of the bird-of-paradise.

APPROACHES

There are many different ways of keeping a sketchbook; some sketches are highly detailed and others created with a fast and intuitive line or economic brushstroke. Your approach will depend on your style and eventual aim. It will also depend on whether you are working in a studio or outside. Flower

Inspiration Quick sketches will, sometimes years later, act as a kick-start to your imagination.

Finding your style The simplest forms such as leaves or stems should be given the same attention as the more spectacular flowers. You will find your style in due course by drawing and painting constantly and by adding, day by day, to your sketchbook.

Artists' advice

Marlene Hill Donnelly (see pages 54–61) recommends a "gesture" sketch to relax your hand and, in a sense, to break the ice and get down the main points of the flower. It should consist of a few loose, gestural marks that map out the main shape and characteristics of the flower. It is not meant to be accurate, but will give you a feeling for your subject.

painters who draw and paint where the
plants grow often have to record information more speedily, since
the weather and light can interfere with their progress, especially
when there are a number of specimens to study. The artist may also
have to improvise, having found the plant in question not quite in
perfect bloom. In this instance the information can be gathered and
combined at a later date with sketches from other forays.

Fine detail The botanical approach sets out to study and record the
flower from every aspect. This includes the physical makeup of the
flower—the arrangement of petals, sepals, leaves, etc.—and the
distribution of color of the various parts. This approach considers
the flower from various viewpoints and in different stages of
development, and in some cases encompasses its habitat. So a
sketchbook page might include pencil sketches of details of the
flower's center, a watercolor exploration of possible techniques for
reproducing the color of the flower head, some color notes on the
leaf greens, and a more finished sketch of the whole plant.

*A sketch a day... Even
on vacation you can
create a personal flower
painted postcard.
There are eight at the
back of this book for you
to enjoy using.*

Shorthand sketches For some,
the sketchbook is about ideas
and potential material for
future finished paintings. A
page might include flower
sketches carried out in a more
cursory manner, recording
shapes and attitudes as well
as information on composition and
mood. A watercolor sketch might be carried out
in line and wash to look at colors and
distribution of tone. There might also
be small thumbnail ideas on
compositional options.

*In the round Painting a flower from all angles makes for
an attractive study, and encourages you to think about
how to portray the 3-dimensional form.*

RECORDING INFORMATION IN YOUR SKETCHBOOK

A sketchbook page can be a combination of a number of different media and techniques, or it might just pursue a single one in particular. You can see the variation in the work of the artists contained in this book: Iris Edey (see pages 70–77) uses only a pen-and-ink line to record the information she needs about flowers for her paintings, while others fill pages with pencil sketches and watercolor workings, punctuating the page with written notes and color swatches.

Dry media Pencil sketches constitute the usual way of exploring form. A pencil line can describe the outline of a flower and explore its three-dimensional form through shading or linear cross-hatching. Dots and other expressive marks can indicate the details of a flower. Colored pencils are useful for more expressive

Botanical
The botanical approach to flower painting involves formal training and a love of accurate painted detail.

Diary
A sketchbook can record your life like a diary, capturing visual ideas and noting gathered information.

Armeri
Echium
Anchu
Convolt
Malva
Chrysa

Coto Donana. May 18
Day 2 of our Andalucian holiday
Bewildering picnic breakfasts in the hotel foyer at 6:30 a.m. before setting off with Claudio and 3 4-wheel drive vehicles for our morning excursion. The woods a riot of colour - but this was a bird day and Claudio wanted us to be on the marsh before 10. Soft haze, birds everywhere.

sketching, and since they are softer than graphite and not as good at recording detail, may also help you to loosen your style if you are becoming obsessed with detail.

Watercolor sketches Making quick watercolor sketches without a pencil guide is a wonderful way to learn to represent form economically with a few brushstrokes. Such sketches will help you to remember the colors and work out the best techniques to use to represent the special characteristics of the flower you are painting. You can use the watercolor paint quite dry or plan it so that while a wash dries you can go back to your pencil sketching.

Line and wash For speed, a quick line drawing in pencil or pen and waterproof ink can be filled out with a watercolor wash to explore color and tone.

Annotations Some of the pleasure and usefulness of a sketchbook is contained in the written annotations you make. These notes will be about the flower you are painting, including its name and any visual characteristics that you want to remember. Notes can be about possible techniques, for example, "drybrush for purple striations" or "spatter for mottled effect." It is also useful to jot down information that will affect the painting of it, such as the date, the weather, and the quality of the light.

Color notes are also invaluable. These can take the form of color swatches and trial mixes or simply of written suggestions of colors, for example, "quinacridone magenta" or "cadmium orange." If you do not travel with a large quantity of paints, why not make a reference chart in your sketchbook of color swatches from your paintbox?

Finally, don't spoil your sketches with notes that are too crowded and be sympathetic to the medium; for example, ink notes on a pencil sketchbook page will swamp it.

Written notes Precious words about colors, shapes, the time, or even the weather can be added to the sketch.

Artists' advice

- Try to develop a sketching habit, such as a page a day or every week.
- Note the direction and quality of light.
- Analyze the structure of the flower.
- Start with some basic geometric shapes, then work in a simple outline.
- Don't use an eraser. If it doesn't work out, simply start again.
- Sketch the details, such as the center of the flower, petal, stalk, and leaves.
- Relax your hand.
- Try out colors and color combinations.
- Remember the sketchbooks in this book are the product of a love of flowers and a desire to capture them in paint.

Learning to look

Every petal of a tulip is different, once you look at it carefully. The irregular striations, a slightly torqued flower head, the curled-under lip of the top edge of a petal—these details give the deeper picture. To see them you must learn to look carefully, letting your eye travel over every part of the flower, comparing one petal with another, analyzing the structure, and all of this before you put pencil to paper.

FLOWER STRUCTURE

To help you understand the structure of a flower, it is worth pulling a few flower heads apart to learn how they are constructed. Study the petals and note how they are joined to the stem. See how they overlap. Hold petals up to the light to see how it shines through, and feel their surface texture. Now look at the flower center, the stamens, and the pistils and their imaginative arrangement. And don't forget to look at the stalk structure—the branching, texture, and color of the stalk.

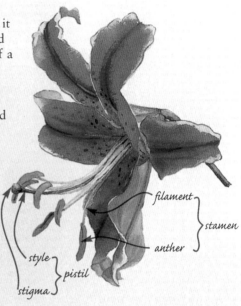

filament
stamen
anther
style
pistil
stigma

Structure of a flower *A lily is a useful flower to pull apart to study the structure—everything is so obvious.*

Trumpet *The inside will appear dark with protruding stamens catching the light.*

Bell *When seen from the side, petal edges will appear light against the dark of the inside of the bell.*

Bowl *Visualize the circle of the upper edge of bowl-shaped flowers. When seen from the side they form an ellipse.*

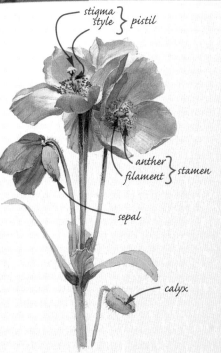

stigma
style } pistil

anther
filament } stamen

sepal

calyx

Careful study *The structure is not always obvious. Look at a number of different-sized flowers of varying types to get the idea.*

Flower shapes The structure of flower heads can be divided into various geometric shapes that will help you to draw them from various angles. These include trumpet (stargazer lily), bell (tulip), bowl (rose), and star (hellebore) shapes. Many flowers can also be broken down into combinations of these shapes, such as the star and trumpet of the daffodil. Flowers can be single-headed (rose), or multiheaded (lilac blossom), or have many spikes or spires (delphinium, foxglove).

Leaves They vary as much as flowers in size, shape, color, and arrangement. You will soon come to recognize particular shapes or arrangements and how they are set on the stalk in a particular pattern. Leaves can rise in a single blade, like the tulip, or be wonderfully intricate like that of sea holly. They can be smooth edged like the waxy, rich, reflective dark green of the camellia leaf, or have a serrated edge like the leaf of a poppy, which can be a gray-green, rough, and hairy. Leaves can be placed on the stalk singly, alternately, in opposite pairs, or in whorls.

Star *Look carefully to capture the variation in size and outline of individual petals.*

Spike *Think of such flowers as cylinders and look at the pattern of light and shade of the overall shape.*

Pompom *Think of pompom-shaped flowers as geometrical globes and add details later.*

MAKING CHOICES

The artist has to make choices all the time while drawing and painting. With flower painting these decisions may be about what flowers to choose and how to arrange them. Will you include every flower head and leaf or will you edit the evidence? What about the scale and viewpoint? Considering your choices carefully will make for more productive flower sketching.

What to paint The flower painter has remarkable freedom when it comes to choosing what flowers to paint. It can be a spur-of-the-moment decision based purely on emotional response. To some degree, if fresh flowers are needed, it will depend on the season and what is in bloom in the garden, or what you can buy from your florist. You may want to choose flowers at different stages of development and include them in a bunch arranged in a vase, which allows you to record the flower from every angle. Or perhaps a single stem in a specimen vase will give you enough information for an in-depth study. When you are just starting out, however, it is a good idea to choose a simple bloom like a tulip or lily.

Choosing your viewpoint Changing your viewpoint can drastically alter the composition of your sketch. Try out some different views to see how they alter your perception of the flower. You can view from above, below, at an angle, or close to. Try drawing and painting small flowers from a close viewpoint, like delicate white snowdrops—if they are painted large scale and close up, they can appear unexpectedly dramatic.

Editing what you see You can edit your cut flowers with a pair of pruning shears, removing all unnecessary blooms and leaves. Then you can just draw what you see in

Attention seeking
Choosing how to represent flowers will affect the reaction of the viewer. This poppy (above) stares at you face-to-face, drawing you in.

Structural editing
Unnecessary detail in this clematis sketch, (right), is edited out, leaving a clean and well-composed image.

front of you. You will soon learn what looks good on the page. It does not have to be symmetrical, but it must look natural. Later, you will get used to editing with your pencil or brush by leaving out blooms or leaves that complicate the drawing, or by rearranging them.

Simplifying detail Editing the structure is not the only choice facing the watercolor flower artist. If you are trying to capture the spirit of a particular flower, it is not necessary to include every minute detail. What you need to do is search for the particular characteristics that distinguish it from similar flowers. It might be petal shape or the arrangement of flowers on a spire, and there is also color. All this information needs to be condensed down in your sketching. You will find that you cannot guess at these details; instead, you have to look hard at your subject to ensure you have achieved the right proportions and the right scale.

With paint, you can suggest detail rather than reproduce it photographically. This means, for example, that you can suggest the seeded center of a sunflower with stippled dots of various colors, or the striations on a parrot tulip by drawing out the color with the brush end.

Choices about light If the purpose of the drawings and paintings in your sketchbook is to help you gather information about different flowers, you need to represent them in an adequate but not too bright light. You do not want the darkest of shadows and the brightest of highlights if it is information that you need to record. A bright light, however, will help you to polarize the tonal range, making it easier to divide up your tonal approach to dark and light, with a mid-tone in between. Artists who are painting outside, whether it's tree orchids in a rainforest or primroses in woodland, will try to incorporate the quality of light into their sketching.

Capturing detail
The confusion of flowers on these pendulous wisteria spikes (above) are captured by touches of dark shadow at the edges.

EXPLORING COMPOSITION

A sketchbook is a good place to explore compositional possibilities for finished paintings of flowers. Try out thumbnail sketches, looking at dominant lines and compositional pathways, cropping options, shape and pattern, negative and positive shapes, as well as color temperature and backgrounds.

Visual pathways It is a good idea to plan a pathway that leads the eye around your painting, perhaps along dominant lines or plotted with highlights or splashes of color. The western eye reads a composition from left to right and can easily be directed around a painting. For example, in a painting of a rose in a vase, the eye could be led along the edge of a leaf and directed to the bloom, then, via spots of red, taken on a circular tour of that area before being ushered out to the right via another strong compositional line.

Organizing the picture space Cutting this flower, (below), with the edge of the "frame" brings it into the foreground and keeps it there so that it does not hang in a vacuum.

Cropping options Try out various cropping options with a viewfinder made from two L-shaped pieces of card. Your subject will usually suggest the shape—portrait or landscape—but it is a good idea to try both. Cropping will allow you to focus in on any part of a flower for a dramatic view, or to pull back to take advantage of more complicated shapes and patterns. Any element of the composition cut

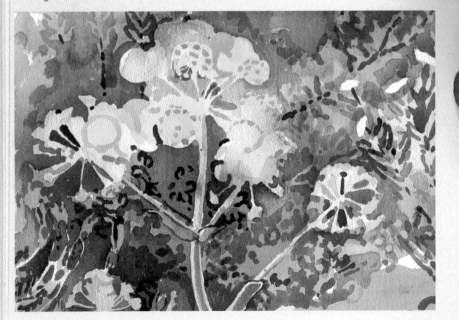

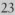

Thumbnail sketches These help resolve compositional issues. Here the artist decided to overlap and add more elements into the foreground.

by the frame of the painting will be brought forward into the picture plane, so a row of plants cropped on either side will dance across the foreground of your picture.

Negative and positive shapes Look at not only the positive shapes of the flower—the bloom, stalk, and leaves—but also the negative shapes in between. These are very important in flower painting and can be manipulated by moving your viewpoint or through cropping. The "positive" edge around a pale flower can be found through a darker "negative" background.

Backgrounds Backgrounds can be very important in expressing the spirit and mood of a particular flower and suggesting habitat. The colors you choose can evoke temperature; for example, cool blues and silver suggest the frosty weather preferred by snowdrops. A textured background can also accentuate the physical characteristics of flowers.

Negative shapes The lilies and the side of the vase are given their shape by the dark background, which cuts in around them.

Choosing and mixing colors

The flower nerine appears to have luminous sparkles built into its pale pink trumpets, which are a challenge for any artist to capture in paint. It is because of such subtleties of color that the watercolor flower painter's palette contains hues that are not always found in other artists' paintboxes. This is because the less a paint is mixed, the more vibrant it will be, so many of the colors found in a watercolor flower painter's collection are ready-made—particularly the pinks, purples, and magentas, such as permanent rose, quinacridone magenta, and dioxazine violet. Obviously you will not need all of the colors illustrated, but showing them will help you to make the necessary choices.

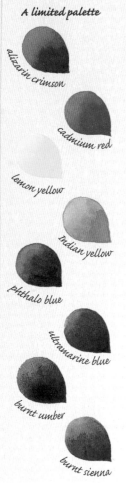

A limited palette

alizarin crimson

cadmium red

lemon yellow

Indian yellow

phthalo blue

ultramarine blue

burnt umber

burnt sienna

Daisy's g.

dioxazine violet

indigo

French ultramarine

cobalt blue

sap green

olive green

raw umber

A limited palette You do not need a vast number of colors, particularly when you are on the move. Remembering that you want transparent colors where possible, a basic palette would contain two versions of the three primary colors—red, blue, and yellow—a warm and a cool one. So you might include alizarin crimson, lemon yellow, and phthalo blue, which are on the cool side, as well as cadmium red, Indian yellow, and ultramarine blue, the warmer versions. Added to these would be burnt umber and burnt sienna.

Mixing colors for flowers It is worth repeating that the less mixed a color is—on the palette—the brighter and fresher it will be. So, how do you arrive at a specific hue? First try and match it with a pan or tube color. Then see if you can modify that color on the paper, perhaps by superimposing glazes, letting washes of one color run into another, or optically, by stippling colors together. Remember that good color mixing takes practice, and

quinacridone magenta

permanent rose

quinacridone red

cadmium orange

new gamboge

transparent yellow

aureolin yellow

requires an intimate knowledge of the behavior of the individual colors in your chosen palette.

Shadow colors Try to keep your shadows as colors, rather than as dull mixes of neutral grays. Add glazes of blue to reds and pinks to make glorious purple shadows that you would find on bright, hot days. White flowers will reflect colors around them in their shadows, so use pale washes of greens from the foliage and blue from the sky instead of grays.

Getting to know your paints It is imperative that you know how watercolors behave. Their translucency is described as opaque, semi-opaque, semitransparent, or transparent. The more transparent the color, the fresher the resulting mixes. Some paints effectively act as stains, making it difficult to lift out highlights; however, a staining color will not come away when you glaze over the top of it, so it does have its uses. For the flower painter, there is also the problem of fugitive paints, which fade or change with time, since it is the "flower" colors that are most susceptible.

The paints A good, basic palette for a watercolor flower painter should include: cobalt blue, French ultramarine, new gamboge, aureolin yellow, yellow ocher, transparent yellow, sap green, olive green, cadmium orange, quinacridone red (or phthalo red), alizarin crimson, permanent rose, dioxazine violet, indigo, quinacridone magenta, raw umber, and Davy's gray.

The sketchbook artists in this book also use: viridian, raw sienna, burnt sienna, burnt umber, brown madder, thioindigo violet, cobalt violet, quinacridone gold, green gold, cobalt turquoise, terre verte, phthalo green, cobalt green, phthalo blue, light red, permanent lemon yellow, Naples yellow, and scarlet lake.

Basic palette *The watercolor flower painter should also consider the colors in this basic palette (above).*

Artists' advice

Ann Blockley (see pages 78–85) likes to start with her basic palette but introduces "guest" colors for specific flowers or moods. Her basic palette includes: French ultramarine; cobalt blue; cerulean blue; Indian yellow; lemon yellow; viridian; raw sienna; burnt umber; warm sepia; cadmium red; alizarin crimson; and quinacridone magenta. The "guests" include: transparent red brown; permanent rose; permanent magenta; raw umber; sap green; and green gold.

COLORS FOR LEAVES

Leaves encompass almost as many colors as flowers, and in so many textures and shapes, all of which have the effect of qualifying the basic color. As with painting flowers, the less mixing on the palette, the better. Therefore, where possible, choose hues that are transparent and mix them on the paper, either by combining colors wet into wet or by glazing one transparent hue over another.

Choosing greens Even green leaves are rarely just green; they usually have areas of highlight that tend toward yellow, and shadowy parts that tend toward blue. You should be looking for these colors when you first study your plant. You will need to decide what hue of green it is, whether yellow-green, red-green, blue-green—in a nutshell, decide which primary color it leans toward—as this will help you choose your paint colors. It is sensible to have some ready-made greens in your palette, such as phthalo green (a blue-green) and sap green (a yellow-green). These can be combined with yellow to make them lighter and blue for shadow areas.

Mixing leaf greens
Here are a few suggestions for the colors you can use to create the varying greens found in plants.

lemon yellow

Yellow-green
Lemon yellow highlights, glazed over with sap green for the mid-green, with indigo added for shadows.

naples yellow

cobalt green

Blue-green
Lemon yellow highlights with a touch of cobalt green, glazed over with cobalt green for the mid-green, with indigo added for shadows.

sap green

phthalo green

Red-green
Naples yellow highlights, glazed over with phthalo green for the mid-green, with burnt sienna added for shadows.

indigo

burnt sienna

Variegated wash Begin with a variegated wash of lemon yellow, raw sienna, and phthalo blue on each leaf. Leave some white highlights and let it dry.

Second wash Paint a second wash of phthalo blue around some of the leaf ribs, adding some veins with the same color.

Creating shadows To further emphasize the leaf ribs, use a stronger mix of the same blue to darken the shadow areas.

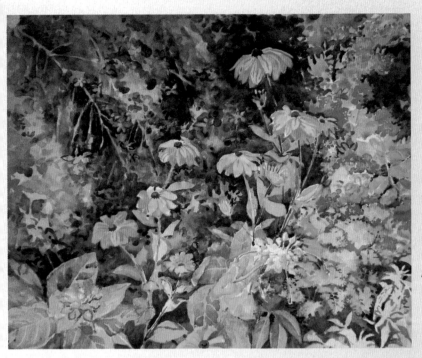

Exaggerating different greens
Create a mass of different greens, all leaning toward primaries—red, blue, or yellow. Here, variation is achieved by exaggerating subtle differences.

Mixing greens Greens can be mixed in the same way as flower colors. A gradual buildup of washes superimposed one over the other will develop the color and the form at the same time. With leaves, you can start with a wash of yellow—a combination of a cool and warm yellow will help with the vibrancy—leaving areas of white paper for the brightest highlights. Once this wash is dry, add a glaze of mid-green or blue, to form the mid-tones. Finally, add a darker blue for the shadow areas.

Reflected color Leaves that have a reflective sheen on them will reflect colors around them. This can be useful in pulling together a painting where the red of the flowers can be taken down into the leaves, thereby connecting the two parts of the image.

Loose wash Colbalt green in a loose wash around the veins can be darkened a little on the shaded side with sap green. Glaze on some lemon yellow when dry, leaving white highlights.

More details Details around the veins are painted in with a mid-toned sap green. Most of the color is concentrated on the shaded side.

Building shadows Make a mix of indigo and sap green and continue to build up the dark shadows with short strokes, using just the tip of the brush.

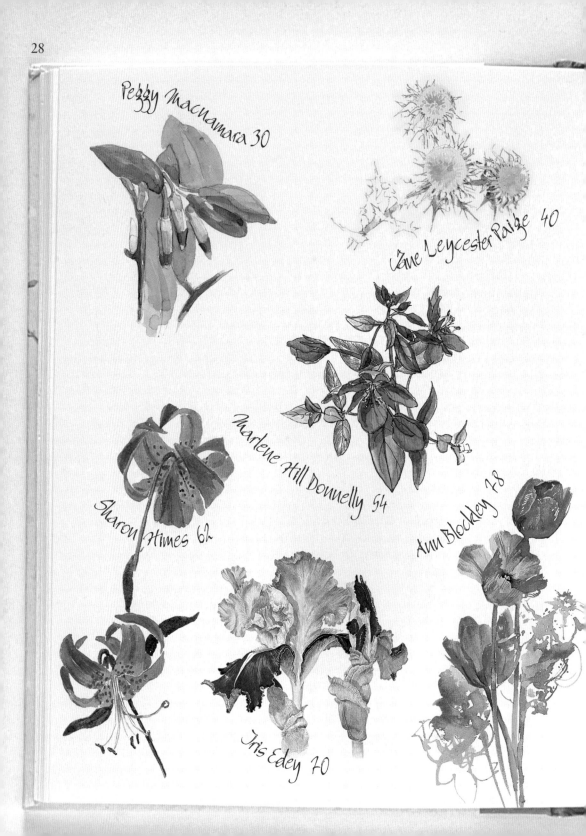

Peggy Macnamara 30

Zane Leycester Paige 40

Marlene Hill Donnelly 54

Sharon Himes 62

Ann Blockley 78

Iris Edey 70

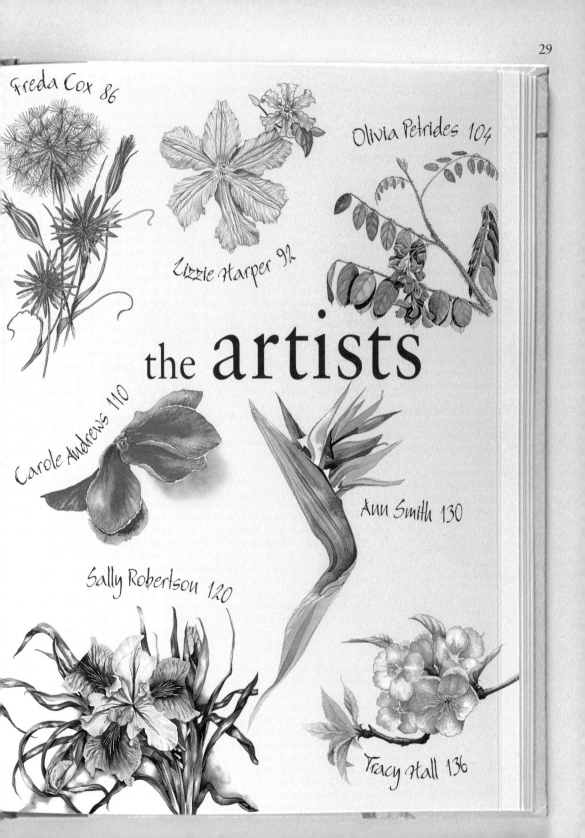

Freda Cox 86

Olivia Petrides 104

Lizzie Harper 92

the artists

Carole Andrews 110

Ann Smith 130

Sally Robertson 120

Tracy Hall 136

> *The Oxford Modern English Dictionary* defines "sketch" as "a rough, slight, merely outlined or unfinished drawing or painting often made to assist in making a more finished picture." I produce more of a sustained sketch. I'm uncomfortable trying to work quickly. It's like recording a glance. I'm more interested in the long stare. Rather than lament my inability to do anything quickly, I've made the slow process my trademark. My sketchbook is made up of slow study pages where I focus completely on my subject and lose myself in the process.

Peggy Macnamara
Slow studies

My pages are about intense observation and gradual understanding, not about speed or an end product. It is a recorded form of active meditation, meant more to give me understanding than anything else.

SKETCHING FOR UNDERSTANDING
There are no labels in museums that say how quickly each piece was completed. Speed is not a factor when determining the worth of a drawing or painting. So why not allow yourself time? Time to develop as a draftsman. Time for technique to become second nature.

Favorite colors

MANGANESE BLUE
THIOINDIGO VIOLET
COBALT VIOLET LIGHT
TRANSPARENT YELLOW
BURNT SIENNA
ALIZARIN CRIMSON
BRIGHT VIOLET
CADMIUM GREEN
VERMILLION

I believe you can discover just how strong a draftsman you can become by taking the time to reach your potential.

I have always been a slow learner, gaining understanding only through repetition. Now I approach my studies in layers, like mantras, making numerous little decisions rather than one big forceful, omnipotent one. I prefer to come up with a first impression of the botanical subject and put it down. Then look again. Edit, look again, edit,

and so on. My study is about slowing down and working successive layers until I can think of no way to make the image better. In a sense I quit when I understand, therefore the work is unfinished.

The greatest part about keeping a "slow book" is that failure is impossible. You are not expected to produce acceptable images, but simply to glory in observation and study. Like the writing in a journal, if your drawing is honest, it is above criticism. 99

PAINTING FLOWERS ANYWHERE, ANY TIME *On these two pages are examples of how you can find flowers to paint, whatever the season: the magnolia, (top left), was painted from a photograph; the bluebonnet sketchbook page, (center), from a nature park in Los Angeles; and the red catstail, (top right), from New Guinea, was sketched in a conservatory in the dead of winter.*

PLANTS FROM ECUADOR
These new species from Ecuador are
painted from botanist Robin Foster's slides.
The plant, from the bromiliceae family,
(bottom left), is food for bears, and the
newly described shrub, (bottom right),
is used by the local population in
"coming of age" ceremonies.

Form and texture The aim here was
to capture the round form and
bristly texture, the two inextricably
entwined. The texture comes with
patient strokes. Don't paint every
spike, but look for unusual
patterns and directions.

Color change Note the
color change between
the top and shadow
underside of the spike.

Capturing leaves Wait until each
layer of light strokes dries before
applying the next. The leaves are
made with yellow and blue first layers,
then detailed with peacock blue and
manganese. Cadmium green light is
then used to heighten.

Building form Bear food from the
family bromiliceae. The cluster of
capsules couldn't just be painted with
transparent yellow. Shadows in the
contact areas were defined with
quinacridone gold, burnt sienna,
greens, and oranges.

Final brightening
Brighten the contrasts
in the final stages
with cadmium
yellow and orange.

Colors of white
Note the variety
of colors in
the "whites" of
this orchid.

Wet in damp
Add orange streaks
when the yellow is
damp so that the
color sinks in. Soften
the edges with water.

Roundness of the berries
Incorporate all the subtle
variations between yellow
and red to express the
round form.

Family ericaceae
The orange seems
brighter when
surrounded with reds
and yellows.

study in violet Cobalt violet with
overlays of manganese pull the
petals back. The perianth comes
forward with Holbein brilliant violet
laid down with lots of pigment. Clean the
brush and soak up excess water, leaving
a thin line to define the edges. Dry
and add cadmium yellow.

Petal edges Try defining
the petal edges with a
brighter-than-normal
hue. Here Holbein opera
does the trick.

SOAKING IN THE BEAUTY
On a cold winter day, these
exotic plants were growing at
the Lincoln Park Conservatory,
Chicago. Orchids everywhere
made it hard to choose which to
paint. The basic transparent
palette includes cobalt violet,
crimson lake, cadmium and
transparent yellows,
quinacridone magenta, and
manganese and ultra violets.

Build up color slowly Use
primarily transparent colors, and
water down every pigment in
order to build slowly.

White coming forward
Dull down the bright green behind the flower with complementary violets.

Peacock & shadow

Rangoon creeper

Water June changes & 2hrs

sapphire

slow layers Light washes of peacock blue and manganese violet with ultramarine are saved for last.

exaggerate Reflected Lgn *suppose shadows & cast*

Lighten & darken later

Leaves surrounding orchids Wash in general large shapes in blues and yellows, leaving chinks of white paper to suggest light. Use more pigment in the later stages to define foreground leaves.

Fullerton Ave Conservatory Chicago

Building the bracts Use as many reds as possible to build the bracts, or base, of the flower; start with a quinacridone red wash, dropping in other colors wet into wet.

Veins first Once the veins are dry, add light washes of opera, magenta, quinacridone red, and alizarin to define the leaves.

Veins last Start with a manganese wash, dry, then define the leaf veins with greens, blues, and red.

Flower highlights Starting with opera and brilliant orange, cadmium orange is used to brighten the areas receiving light.

Textured leaves Creating texture on leaves requires many layers. Follow the progress from left to right.

Ecuador Plant

ANT GARDEN The green leaves protruding from this ant garden were a challenge for the artist. She began with reds, blues, and yellows before using greens.

Creating greens Complementary colors glazed over each other form neutrals. Here red over green creates the dull green so often seen in nature.

Building the nest The nest grows from many layers. Lay down the common gestures, let each layer dry, and then reapply.

First washes
STAGE 1 When faced with a range of green hues, begin with washes leaning toward primary red, yellow, and blue.

Middle washes
STAGE 2 Use the middle washes to bring the color gently back toward green, but you can still see the primary origins. The artist directs her efforts toward finding the subtle differences in each of the greens.

Final washes
STAGE 3 Finally, try to show what the leaf is doing: if it is coming forward give the tip a crisp edge; if it is receding, leave it in an unfinished state.

BIRD-OF-PARADISE
The bird-of-paradise studied from
four different view-points.

Gestural drawings
STAGE 1 These gestural
sketches capture the essence
of the plant, and remain
technically correct.

First washes
STAGE 2 Manganese blue and transparent yellow
are touched in with brilliant violet and orange,
exploring how the birds-of-paradise dance about
and their relationships to each other.

Flower to flower
STAGE 3 Working on a few flowers at
once takes the pressure off getting the
color exactly right. Keep moving
from one flower to the next, to
simplify and get it right.

Building up washes
STAGE 4 Hooker's
green, yellow, and
violet, and a
graduated wash from
yellow to ultramarine blue create a
lit and shadowed bract.

Final washes
STAGE 5 Details of the leaf
are defined with the
final, carefully applied
washes. The artist
"resorts" to alizarin
crimson for the stems and
the open areas of the beak.

White highlights
Because they are
surrounded by more
color, the white
highlights on
the orange
sepals have
added power.

Completing the bracts Brilliant
violet is glazed over the bracts to
vary their color. Each bract is
unique, though comprised of the
same ingredients.

EXPRESSING LIGHT THROUGH COLOR

EXPRESSING LIGHT THROUGH COLOR
*The artist wants to express the silvery light
of the early Mediterranean summer and the
jewel-like quality of the tragopogon, (left).
She chooses cerulean blue, aureolin yellow,
and alizarin crimson.*

Jane Leycester Paige

Wild flowers as they grow

Favorite colors

BURNT SIENNA
PERMANENT ROSE
SCARLET LAKE
RAW SIENNA
AUREOLIN YELLOW
WINSOR OR LEMON YELLOW
COBALT BLUE
ULTRAMARINE BLUE
CERULEAN BLUE
VIRIDIAN

"Ever since I can remember I have been interested in drawing, painting, and nature. More than anything else, I love to be outside, and I particularly like the way plants grow in their chosen habitat. The incidental sounds that go with what I see—the bees visiting the flowers, the birds getting on with their business around me—add to my sense of happiness and concentration.

PACKING UP

Sometimes I paint in the garden, in which case I can spread myself out and use large pieces of paper, large brushes, and several dinner plates for palettes. Often, however, I walk some distance to where I want to paint and may be out all day.

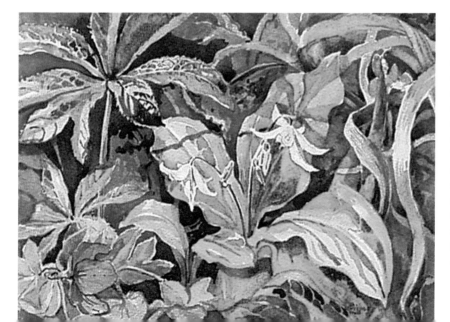

RADIANCE IN THE SHADE
These dogtooth violets were painted in the artist's garden during the two or three hours of good light that were available each day. To make the violets shine out, as they do in such a shady corner, superfluous white paper, in areas other than the flowers' heads, are covered with paint.

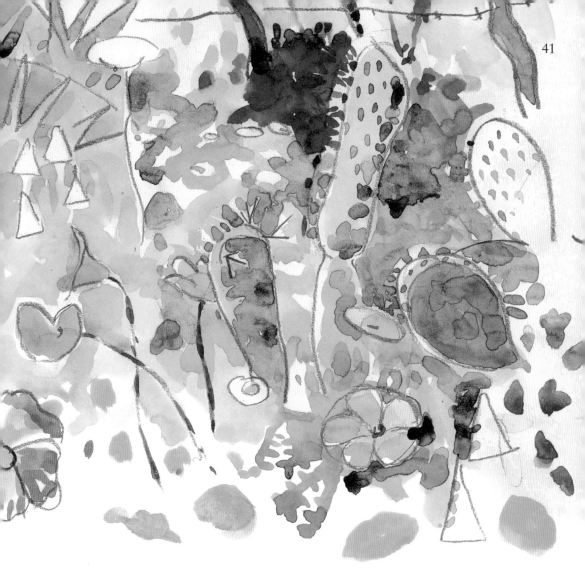

Then I must restrict myself to what I can comfortably carry in my backpack, not forgetting a thermos flask, stool, coat, and hat. In one pocket I keep a plastic water bottle with its own cup, so that I have plenty of clean water to paint with. My little metal paintbox, stocked with nine Winsor & Newton artists' quality watercolor tubes, fits into the other pocket. Insect repellent, a magnifying lens, towels, and plenty of clean paper complete the kit.

I am drawn to the shape of things, whether a landscape, a still life, or the intricate practical design of a single plant. In my sketchbook I will use a pencil, making tonal notes and adding touches of color if helpful, but when painting I prefer to go straight in with a brush, the bigger the better. I love the way you can make a fine line or a broad area of color with the same brush. 🙶

ROADSIDE FLOWERS, SOUTHERN SPAIN *The freedom of working in a sketchbook combined with the urgency of not having much time has resulted in the almost abstract quality of this sketch. The sheer delight of the random geometric shapes and the complementary pinks among fresh greens is intoxicating.*

Creating form The shadow washes around the cowslip shapes create the form.

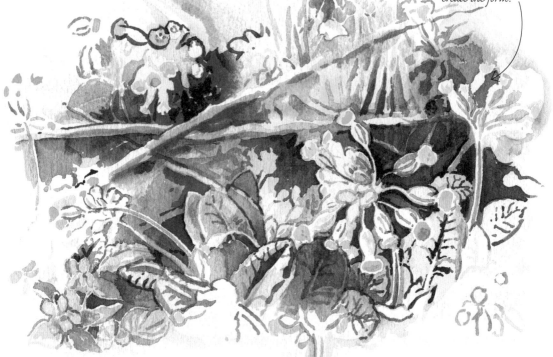

Complementary colors Yellow cowslips interspersed with violets were painted in the late afternoon sun. The deep violet shadows add to the "zing" of these complementaries. The shapes are drawn with the paintbrush and the spaces built up tonally as the painting progresses.

Woodland flora These woodland flowers in Sierra de Gredos, Spain are intimately observed in a way that is beyond photography. Simple washes of color explore these woodland plants.

Building up negative spaces (right) Making the positive white by building up the negative spaces between flowers is a challenge. This pair of narrow-leaved helleborines at the edge of pine woods in the Sierra de Gredos, Spain could only be painted when the sun had found its way through the canopy.

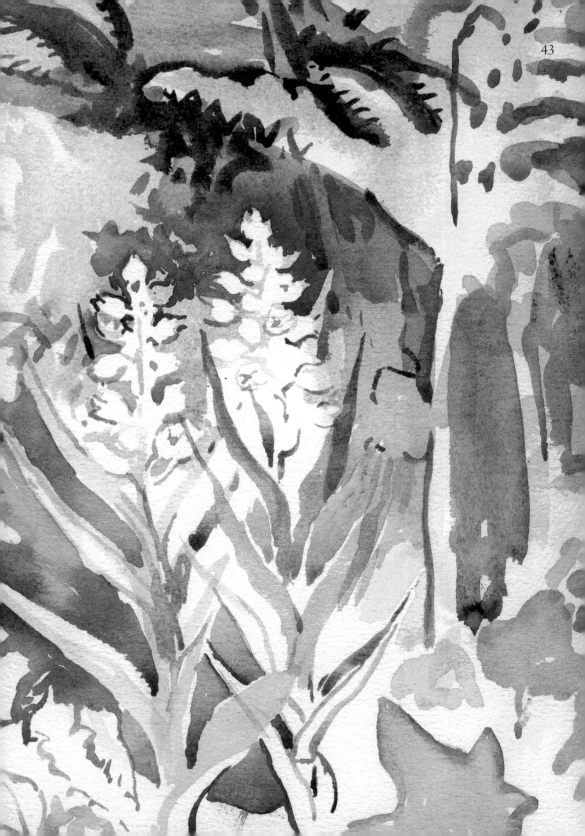

BACKGROUND PATTERN
Plants in the wild are often wonderfully camouflaged. This striking pair of lady orchids was posing against an ivy-and-lichen-covered oak trunk. This background became an important part of the painting.

Detail for focus The orchid heads have to be painted in more detail so that they stand out from the background.

Shaping the foreground Background colors come in around the orchid stems to describe the form.

Scale The ivy leaves in the background, carefully observed, help to set the scale of the orchids.

Harmony of color The tiny bee orchid survives by sinking into a background of similar colors. As the artist loads her brush with the pink of the petals and the red/brown of the labellum, she looks for places to use the same colors in the background, building up a harmony of color with a very limited palette.

Simple but not easy It took the artist three days to complete this painting, as it took time to find the shapes accurately by "drawing" directly with the brush.

Composition The vulnerability of the orchid is suggested by the setting.

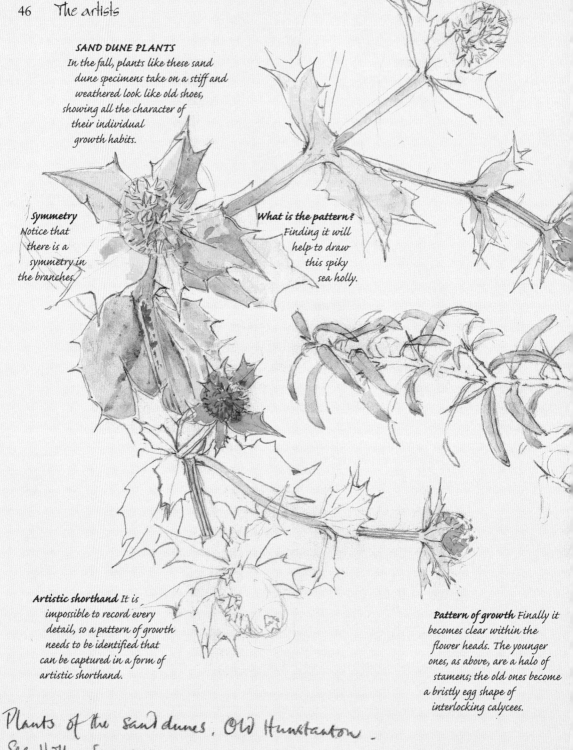

SAND DUNE PLANTS
In the fall, plants like these sand dune specimens take on a stiff and weathered look like old shoes, showing all the character of their individual growth habits.

Symmetry Notice that there is a symmetry in the branches.

What is the pattern? Finding it will help to draw this spiky sea holly.

Artistic shorthand It is impossible to record every detail, so a pattern of growth needs to be identified that can be captured in a form of artistic shorthand.

Pattern of growth Finally it becomes clear within the flower heads. The younger ones, as above, are a halo of stamens; the old ones become a bristly egg shape of interlocking calycees.

Plants of the sand dunes. Old Hunstanton.
Sea Holly - Eryngium maritimum.
Sea Buckthorn - Hippophae rhamnoides

Perspective The leaves are tricky to get right since they grow in an uneven spiral around the twig.

Berry clusters No flowers here, on the sea buckthorn, just the distinctive clusters of fruit growing around the stem, glowing rich orange against the faded gray-green of the leaves.

Bronzed suns Each carline thistle has three bronzed "suns" borne on tarnished silver stems.

Color unity The artist believes that by using the same three colors in different permutations, the plants on this page look as though they have all been weathered by the same air.

Texture Contrasts are sought between the brittle prickliness of this plant and the soft golden centers of the flowers.

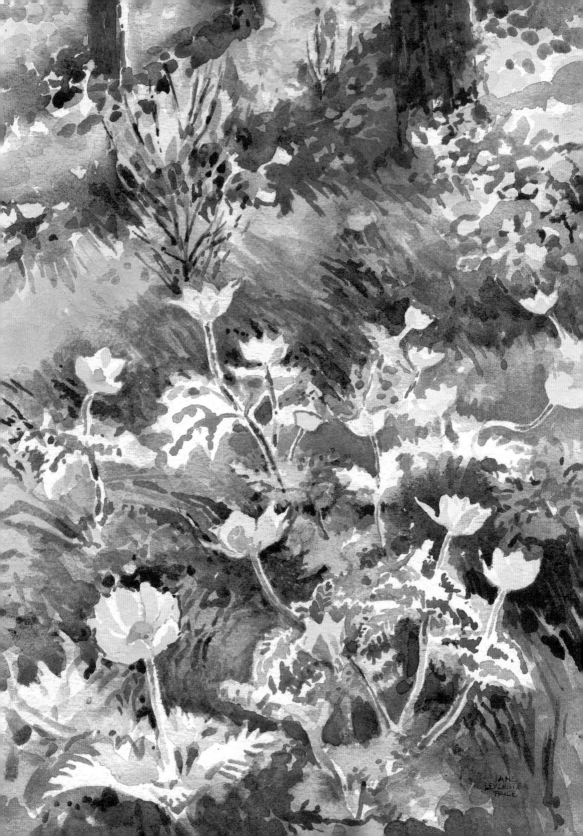

CARPET OF PULSATILLA

An astonishing sight: a whole hillside of natural pinewood glistening yellow with the rare yellow pulsatilla, striped diagonally with shadows from the trees. Painting it was for the artist an exquisite pleasure, sitting quietly in such a lovely place, deer creeping, kites on display overhead, and a fox languidly making its way along the fence.

Positive and negative shapes

STAGE 1 Using a watery solution of aureolin yellow, plot the left-hand flower as a positive shape. For the other, paint a blended, wet-into-wet yellow patch, leaving a white space for the stem and leaves. When almost dry, lightly "find" the shape of the flower with a superimposed watery wash of cobalt blue.

Suggesting texture

STAGE 2 Strengthen the flowers and develop the leaves with additional washes, reserving areas of white paper for the strong sunlight reflected off them. Begin to suggest the hairiness of the stems by stippling onto the stem, on the left, and by exaggerating the texture along the stem edge in the background green wash.

Linking parts through color

STAGE 3: Take a touch of crimson (permanent rose), which is pure on the stems where they support the leaves, into the background as a link by mixing with viridian for the deep shade behind the flower.

Sketchbook studies

Careful studies in the artist's sketchbook are invaluable reference material, allowing her to be more experimental in her painting.

The Artist at Work

Building a successful composition

Jane Leycester Paige has an instinctive feel for flowers. She can describe them in paint with what seems like very little effort, but her simplified flowers come from a deep knowledge of their structure and their habitat. Holding the disparate flowers together in this charming composition is another great talent. She succeeds in her aim in capturing the spot where she found these flowers— in a sunny meadow in southern England—even though she is painting them, fast drooping, arranged in a pot.

Grasses, sorrel, musk mallow, self-heal, hop trefoil, and black medick: these wonderful meadow flowers were picked from a single patch in late June.

PALETTE

Permanent rose
Cobalt blue
Aureolin yellow
Winsor violet (a touch was used in the mallow and self-heal)

This is the artist's paintbox as it looked at the end of the project, with the three colors in the pans at the bottom. Most of the mixing is done on the paper, adding one color wet into wet into another to create a varied palette.

1 Compositional considerations
A rough sketch sorts out some of the compositional ideas for the artist. The flowers in the pot will not be painted exactly as they stand, but will be "arranged" into a composition that works on the page. This sketch is not used under the painting.

2 Plotting the colors
Working quickly, the artist first plots the main flowers and colors around the page, using the primary colors diluted but pure. Now the artist starts to construct the flower shapes, sometimes negatively with background greens, as here with the mallow flower.

3 Negative shapes *The background green describes various flowers, changing color and tone as the yellow and blue run together in differing amounts. You can see the wash is quite wet and the brush quite large (round, sable, size 6), keeping the approach broad. Look for the light and paint the dark.*

4 Building structure It is a balancing act to maintain the clarity of the color in the flower heads and build up the depth of background tone without muddying the colors. Here, a brown/red wash encircles the yellow hop trefoil to bring it into focus.

5 Brighter colors The color is concentrated in the central part of the painting, with less intensity and detail around the edges of the composition. The individual flowers of the self-heal are built up with bright, pure color, a detail added over the now-dry initial wash.

6 Linking with color Right in the center of these flowers, a bright patch of red carefully painted around the flowers and behind the stems draws the eye into the depths and links with other similar reds in the sorrel and elsewhere in more neutral forms around the page.

7 standing back Gradually the painting is built up. It is like a never-ending journey around the subject, exploring and developing. Note how superimposed washes create new parts of the structure, such as the yellow grass stems to the left of the main mallow flower. Standing back, the new bright colors at the foot of the central section will need balancing with similar intensities of color in the area. The outer edges of the painting require development, too.

8 Building up the outer reaches First the mallows on the left side need working up. Drawing with the brush, a silver-green mix describes the filigree leaves. The flowers here are seen dark against light; the stalk is reinforced, but it is a broken line as if caught by the light.

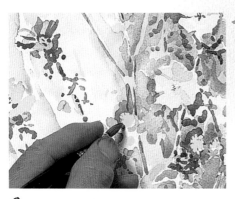

9 Repeating washes Developments in the early stages, completed with pale washes, have to be repeated, building up the color and, more important, the tone. It will sometimes take many layers to reach the right balance when seen as part of the whole painting. Note how the buildup of washes is creating an intensity of color in the central section but the tone is well balanced. Note also how important the reserved areas of white paper and paler pure colors are, bringing light into the painting.

10 Overall simplification You can see how the detail on the mallow flowers is cumulative. It isn't necessary to paint every flower with the same amount of detail. The power of light extinguishes detail or highlights it, and this inconsistency is true to nature. Note how the painting is developing outward from the center.

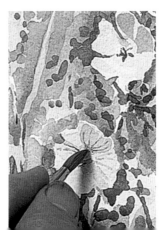

11 Mallow detail Just on this one flower, the artist chooses to show the characteristic veining on the mallow petals. Using the finest hairs on the tip of the same large brush, she paints in these veins with pure, dry color.

12 Flowers in their meadow

The final painting is a
glorious patchwork of shape
and color. Having such a
restricted palette ensures that the
painting has a cohesiveness—the
colors naturally link together as they
all come from the same three primaries. The last background
washes have been applied in small broken patches at the
bottom right and act like energy waves in what might have
been a still area.

Marlene Hill Donnelly
Sketching in the field

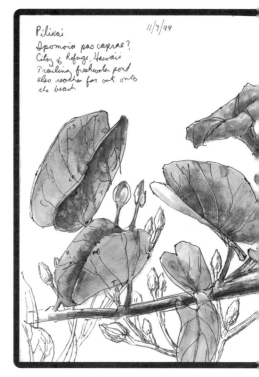

Pilikai
Ipomoia pas caprae?
City of Refuge, Hawaii
Trailing freshwater pond
also reaches far out onto
the beach

11/7/99

"Field sketching is a very personal and meditative experience, with an intimacy and immediacy that only the natural environment can bring. It thrills me to sit on the ground, eye-to-eye with the flowers, wanting to become part of their world. Lying flat on a snowpack to paint glacier lilies, sitting in an ice-melt stream for mountain marsh marigolds, or even crouching in mud for skunk cabbages, life doesn't get any better. Rain and snow pelt my sketchbooks, bog ooze spatters them, and a chipmunk once left multicolored footprints as it sprinted though my paint and across the page.

SKETCHING WITH ALL THE SENSES
I draw and paint trying to use all my senses, noting birdsong, droning bees, the rustle of small mammals. I also write in my sketchbook about the weather and sky, and even the ground, sometimes soft and welcoming, sometimes rocky and inhospitable. I add notes

MAY APPLE FOREST
In a secret, self-contained world beneath these spring flowers, the rare and whimsical morels add to the implied magic felt in this alternate universe of plants in their native habitats.

favorite
colors

AUREOLIN YELLOW
ORGANIC VERMILLION
PHTHALO CRIMSON
ALIZARIN CRIMSON
QUINACRIDONE VIOLET
ULTRAMARINE BLUE
PHTHALO BLUE AND GREEN
BURNT SIENNA

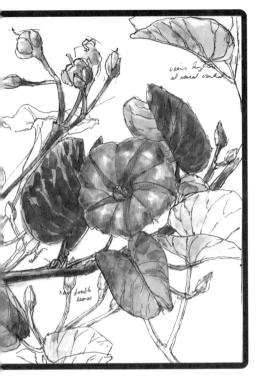

IPOMOEIA *The powerful Hawaiian sun reflecting off the white page can be blinding. A traditional artists' white umbrella is impractical as it is too heavy to carry on long hikes, but a wide-brimmed hat and neutral tinted sunglasses are helpful. It is better not to try and finish such sketches on the spot because the color always appears vastly different under more standard viewing light. Instead, complete about 75%, bringing them back to the studio for completion. Color notes made on location aid this process.*

on color and lighting as well. These are all pieces of the plant's world and this research feeds into the finished paintings. Reading my notes at a later date and studying the sketches brings me back to the experience much more fully than looking at images alone.

The personal nature of outdoor sketching silences my perfectionist inner critic. I draw directly with pen: no pencils, no erasers. I begin with a light gesture drawing and in the final piece these marks appear beneath the paint as "energy lines" adding a feeling of movement. I follow with a more deliberate contour drawing to establish details quickly. Then I apply watercolor in light layers that dry quickly in the breeze. I "code" my subject in the first wash: pale cool color where light is reflected, warm where transmitted. I code shadows in darker colors. If I run out of daylight, the coding tells me how to finish accurately in the studio. 〞

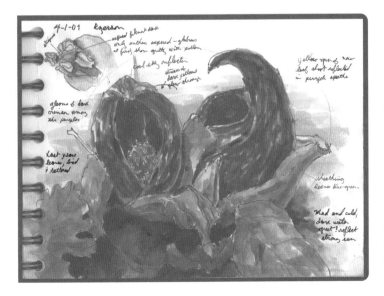

SKUNK CABBAGES *These strange, ill-perfumed plants are the first harbingers of spring in U.S. north-eastern forests. You have to work hard at painting the colorfully dark mud, and wet, decaying leaves that are such an essential part of their habitat.*

OBSERVING LEAVES

Taking the time to sketch leaves is as important as painting flowers. Watch their growth patterns, whether alternate, opposite, or whorled, and draw them from varying angles.

Habitat notes The artist's notes help her to recapture the essence of these willow herbs in the later finished paintings.

Leaf color Notice the color of leaves, whether the blue-green of the broad-leaved willow herb here, or the more standard green of most plants.

Observe the leaf axils Often something beautiful and scientifically important is going on in the angle between leaf and stem.

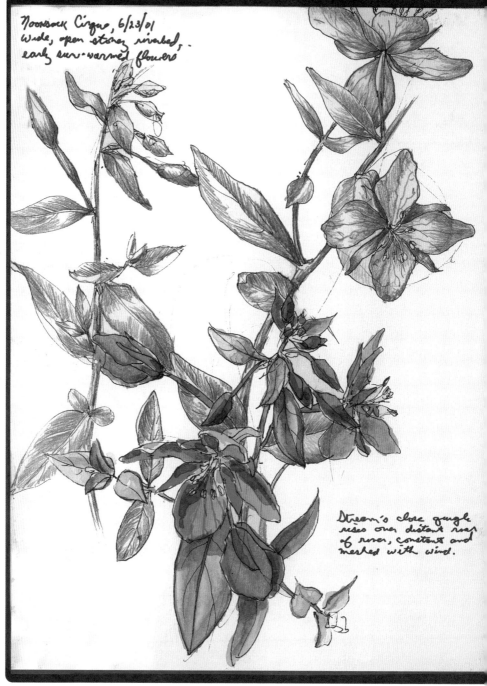

Noonsock Cirque, 6/23/01
Wide, open stoney riverbed,
early sun-warmed flowers

Stream's close gurgle rises over distant roar of river, constant and meshed with wind.

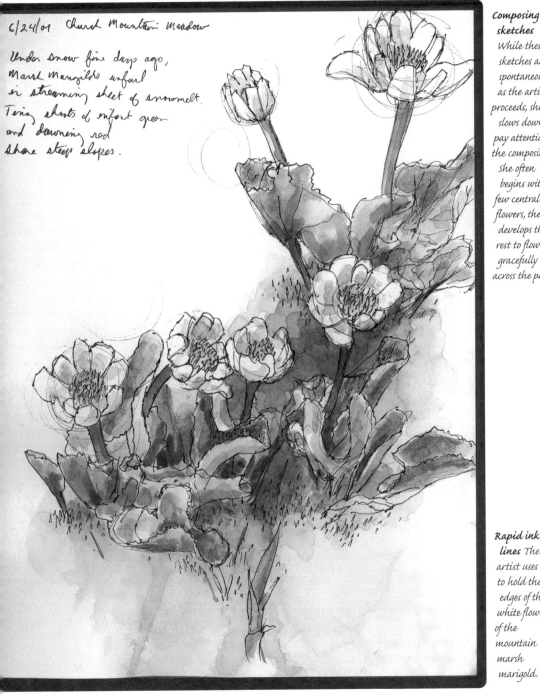

6/24/01 Church Mountain Meadow

Under snow five days ago,
Marsh Marigolds unfurl
in streaming sheet of snowmelt.
Tiny shoots of infant green
and downing red
share steep slopes.

Composing sketches
While these sketches are spontaneous, as the artist proceeds, she slows down to pay attention to the composition. She often begins with a few central flowers, then develops the rest to flow gracefully across the page.

Rapid ink lines The artist uses ink to hold the edges of the white flowers of the mountain marsh marigold.

STUNNING SKETCHBOOK PAGES

Each page of these sketchbooks is a work of art, featuring naturally composed studies of flowers where they grow.

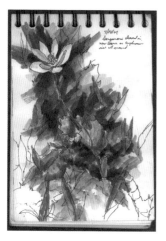

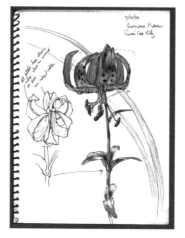

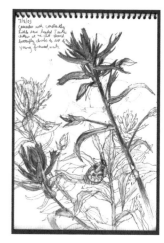

strong background Such a delicate white early spring flower, sanguinaria, needed to be highlighted by a strong dark background.

Artist's pigments This prairie jewel, the Turk's cap lily, required pure red and orange pigment for its brilliant color. Never skimp on the quality of the paint, even for simple sketches.

Passing wildlife A chilly morning slowed down this butterfly resting on the leaves of the Indian paintbrush, enough to let the artist sketch him.

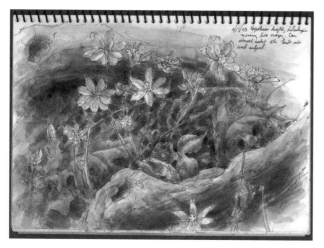

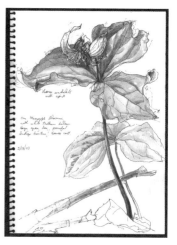

Contrasts in nature The phoenixlike rise of hepatica blossoms, fresh and shining above the tattered dead leaves of winter, is a welcome sight in earliest spring. While most of this sketch was completed on location, the strong darks were developed later in the studio under controlled lighting.

White-flowered plants This nodding white trillium can be painted from an angle that places dark leaves behind white petals.

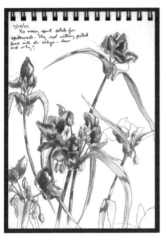

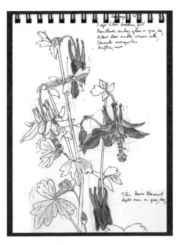

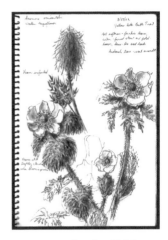

Lighting Pay close attention to lighting. These prairie plants, spiderwort, look most natural with the sun shining through their leaves.

Ink sketches Showing the configuration of petals and leaf bases, these ink sketches provide invaluable information for finished paintings. These complex columbine are shown in all stages.

Anemone These fanciful flowers were blooming in the sharp boulders of a recent avalanche, soft and delicate in the midst of a harsh habitat.

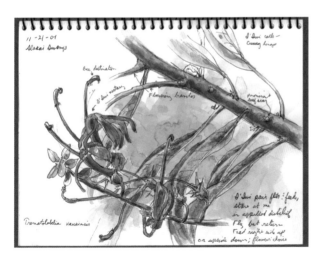

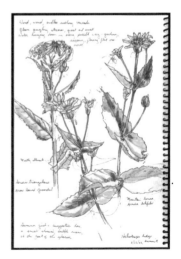

Endangered bloom Sketched on a rare sunny day, warm light streaming though leaves and petals, this endangered Hawaiian native blooms for the scarlet I'iwi birds in the wettest place on earth, the Alakai Swamp on Kauai. The artist has a separate sketch kit that works in the rain, or even under water, but it does not include watercolors!

The power of sunlight At high altitude you can capture the near white of reflected light and the strong yellow-green of light transmitted through the leaves of mountain arnica and senecio.

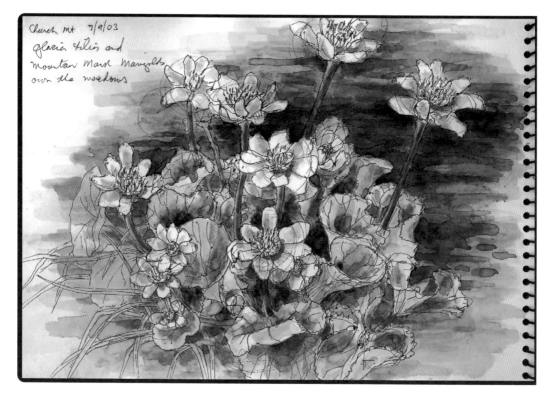

Church mt 7/9/03
Glacier lilies and
mountain Marsh Marigolds
over the meadows

PAINTING LIGHT

Plants and light are inseparable. The aim in this painted sketch of mountain marsh marigolds, as in all the artist's other work, is to convey the feeling of sunlight shining on and through the leaves.

Capturing a likeness

STAGE 1: Use fine energy lines to establish gesture, size, and proportion. Next, let a more controlled contour drawing define the edges.

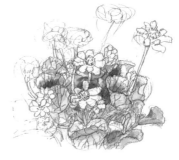

Coding for light

STAGE 2: Code the sketch with pale washes: cobalt blue where light reflects off leaves; high-intensity yellow-green for areas of transmitted light; and a mix of phthalo green, aureolin yellow, and burnt sienna for shadows. Leave highlights white.

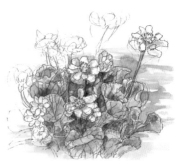

Vibrant shadows

STAGE 3: Build on this base by strengthening the values. Layering with complementary colors will create a vibrancy in the shadow areas.

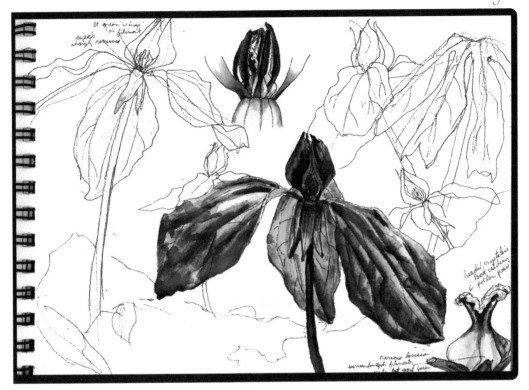

Magnification *The artist carries a 10x magnifying loupe to study and paint close-up details of her subject, such as this red trillium.*

4/8/01

Emerging cup-plant· winged embracing petioles in place – confident, reaching

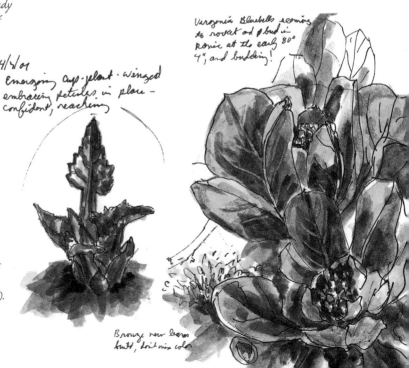

Virginia Bluebells seeming to rocket and 0 bud in a panic at the early 80° 4", and budding!

Emerging flowers *There is something magical about emerging plants such as this cup-plant, (right), and the Virginia bluebells, (far right).*

Bronze new leaves hard, don't miss color

"Woodlands have set my direction as an artist. When I walk the nearby nature trails, I am a child again, finding the small treasures that tell the stories of the forest. A feather or piece of lichen, a wild orchid, or a strange insect can capture my attention and curiosity. For me, drawing and painting these finds are ways of understanding their form and function.

Sharon Himes

Experiencing nature through sketching

In my art I strive to capture the experience of nature, the joy of discovery and the fascination I find in pattern and texture. Tangles of vines and branches, brambles and thickets are like a wild tapestry, weaving colors and textures into a rich and intricate whole. In painting them I strive for a balance between botanical realism and abstract design, to celebrate the exuberance of nature.

SEASONAL SKETCHBOOKS

My journals and sketchbooks are arranged not chronologically but by seasons. Notes and sketches from one year are jumbled with past entries for the same month or day over many years. This gives me a view of the forest through a progression of seasons,

COMPLEX SHAPES *Each Turk's cap lily head has six petals that curve back and create the effect of a traditional Turkish headdress. To simplify complex shapes, divide and conquer: pencil in the nearest petal in relationship to its size and place in the whole. Then use that one as a guide for the other petals.*

HOLDING THE FLOWER *It helps to hold the flower next to the sketch to compare curves and overlaps and to depict it life-size.*

WILD IRISES *are refined shapes compared with their fancy domestic relations. The flower buds open like butterflies, unfurling each damp and wrinkled petal in a particular sequence.*

WATCH THE ANGLE
As the flower matures, the angle at the base of the flower changes and the iris holds its head with a different attitude.

and I look to the sketchbooks to learn when flower favorites will emerge again, and where to find them.

I use a magnifying glass and small microscope to delve deep into a plant's secrets and I follow my curiosity into many fields along the way. Drawing and painting the seeds, fungi, and lichens gives me an understanding of the secret lives of wild orchids and other forest wildflowers.

I invariably paint from life and must paint quickly while the materials are fresh. I strive to be true to scientific reality but do not necessarily paint in a highly detailed style. It is more important to show the attitude of a plant and depict its growth habits realistically by giving an impression of detail. I rarely paint garden flowers, preferring to paint wildflowers in a natural setting, and never cut them or place them in a vase. **"**

IRIS LEAVES *The soft green iris leaves contain many bluish tones, especially where they reflect water or sky.*

Favorite colors

QUINACRIDONE GOLD	COBALT BLUE
NEW GAMBOGE YELLOW	COBALT TURQUOISE
WINSOR RED	PERMANENT ROSE
TERRE VERTE	WINSOR BLUE
SAP GREEN	FRENCH ULTRAMARINE BLUE

SKETCHING VIOLETS

Early spring flowers, violets, are simple shapes, with only five petals set against heart-shaped leaves. With a background of dark green leaves, they glitter like small gems. Painting violets is as much about painting their leaves as it is about the small flowers.

Where to start? *Sketch in the flowers but begin painting the leaves first.*

All-around view *Look at the plant from all directions.*

Characteristics *Note how the gracefully curved stem attaches to the flower from the back and the green sepals wing out behind the flower.*

Violet leaves *Leaf colors range from yellow-green through blue-green. Try terre verte, cerulean blue, and sap green. Note the dark shadows in the background worked in around the leaves and flowers to bring them sharply into focus.*

Petals Paint the petals one at a time with almost any combination of rose and blue. Rather than using a single tube color, such as dioxazine violet, mix the violet on the paper. Try quinacridone magenta and ultramarine blue, or permanent rose and cobalt blue.

Vibrant violets To create truly vibrant violets, dampen a small brush with dilute rose on one side and blue on the other. Paint a petal with the two colors in the brush, using only one stroke per petal.

Contrasts Showing the brown leaves from which the violets emerged provides contrast and sets their location in a forest.

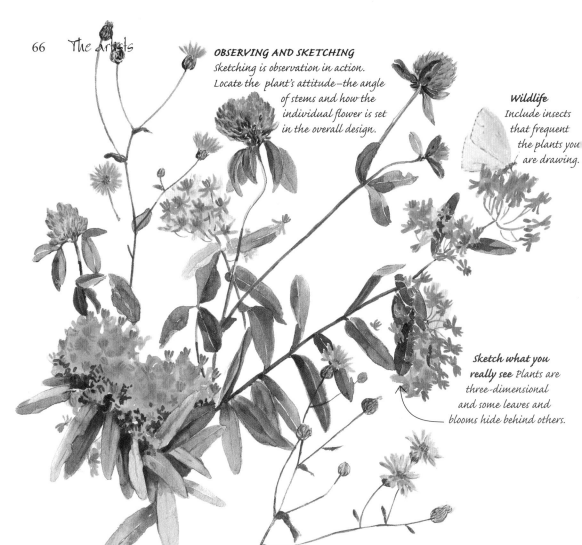

OBSERVING AND SKETCHING

Sketching is observation in action. Locate the plant's attitude–the angle of stems and how the individual flower is set in the overall design.

Wildlife
Include insects that frequent the plants you are drawing.

sketch what you really see Plants are three-dimensional and some leaves and blooms hide behind others.

CREATING TEXTURE

Butterfly weeds range from yellow to red-orange and consist of clusters of small flowers, each with five petals up and five down. Build up the texture of these clusters in three steps.

First underlying wash
STAGE 1: Paint in the leaves. Once dry, suggest the mass of flowers with a wash of yellow. Touch the damp color with orange variations to give depth.

Blurred flower shapes
STAGE 2: Allow to dry, then repeat a light yellow wash with a little green. While damp, lightly sketch the flower shapes using a semi-dry orange.

In-focus flowers
STAGE 3: Allow to dry, then add more red-orange flowers with a dry brush to indicate in-focus flowers. When dry, add tiny green stems to some of the flowers.

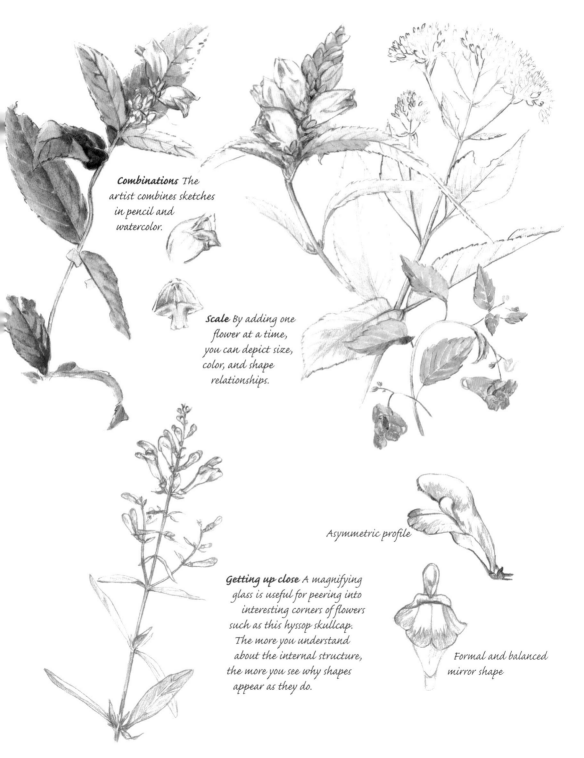

Combinations The artist combines sketches in pencil and watercolor.

Scale By adding one flower at a time, you can depict size, color, and shape relationships.

Asymmetric profile

Getting up close A magnifying glass is useful for peering into interesting corners of flowers such as this hyssop skullcap. The more you understand about the internal structure, the more you see why shapes appear as they do.

Formal and balanced mirror shape

DELICATE WHITE FLOWERS

A white flower can only be as white as your paper, but it can disappear into it. These white flowers are described through their shadows or placed against a dark background that will explain them as a negative shape.

Neutral tints White flowers, like this bloodroot, need shadows to give them shape. Mix two neutral tints with any three primary colors, the more transparent the better, making one cooler and the other warmer, and use these to add the shadows. Winsor blue, (green shade), permanent rose, and quinacridone make a good transparent neutral.

Colored whites
White flowers can contain subtle tints of pink and ivory, like this bellwort, or blue, which show in soft shadows.

Tonal values The artist first sketched the spotted wintergreen in pencil to work out its tonal values.

Pencil marks When sketching in pencil, use dots and dashes rather than solid lines, and avoid outlining the flower.

Warm and cool neutrals *You can see warm and cool neutrals in the shadows of the trumpets of this hedge bindweed.*

Flower clusters *Clusters like this honeysuckle can contain blooms at various stages. Hold the cluster at eye level to determine the direction in which each flower part is going. Sketch them one at a time from nearest to farthest.*

Colored undersides *Even white flowers have colored undersides. Arrange leaves behind white flowers to highlight them, as with this dwarf trillium.*

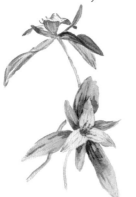

PEN-AND-INK STUDIES
*Drawings from live plants
create the foundations for
this artist's work. Her
preferred sketching
medium is pen and ink,
for which a smooth
surfaced, cold-pressed
paper is best.*

**SKETCHING WITH
PENS** *Fiber-tipped pens
allow control over the
stroke width, essential
for these tendrils.*

Iris Edey

Love affair with nature

*Favorite
colors*

ULTRAMARINE BLUE
CERULEAN BLUE
WINSOR VIOLET
ALIZARIN CRIMSON
CADMIUM RED
CADMIUM YELLOW
LEMON YELLOW
BURNT UMBER
SCARLET LAKE

"From a very early stage, my art has been built around a love affair with nature. I have been so awestruck by the perfection of form and function to be found throughout the natural world, that for over twenty years I have devoted myself almost exclusively to capturing flowers as accurately as possible. I have never had cause to doubt that if the results are accurate, they will also be beautiful.

A LEARNING CURVE

The search for a technique that would do justice to flowers took several years of practice and experimentation in oils, tole, sumi, pastels, and so on. It soon became apparent, though, that only transparent watercolor had any chance of yielding the clarity and strength I required. However, it still took years of reading and painting to learn how to use color and to gain adequate control over paint and water. During this time it also became clear to me that my

CYCLAMEN WATERCOLOR *A passion
for detail can be seen in the artist's
finished paintings. Based on pen-and-
ink studies, such paintings are carefully
planned and executed.*

PLANT ARCHIVE
*The artist has collected
an archive of plant
sketches, from rain
forests and tundra,
as well as from
airport lounges.*

painting had to be rooted in detailed sketching, which
is only really effective if done from life and, for me, in
pen and ink. Sketching not only provides the form of
the flower, but also forces me to concentrate on my
drawing, which enables me to remember the key
colors so I can paint them years later. I am
convinced that, if you cannot or will not draw, you
will not be very successful in watercolor.

Although transparent watercolor is a demanding
medium, it offers a generous level of
satisfaction to the artist who is
prepared to invest the necessary
time and effort. **99**

USING PEN AND INK
*The obtuse legginess
of this geranium is
faithfully recorded in
a pen-and-ink sketch.*

Leaves and stems Leaf and stem color goes from blue in the background to yellow-green in the foreground.

Florets Studying floret details will guide you to pattern shapes that help with the painting.

Simplify the form Working in pen and ink forces you to simplify what you are sketching.

LAVENDERS
Patient attention to detail at the drawing stage will help you to capture the individual characteristics of any flower. The lavender examples here show how much detail matters; florets, leaves, and stems all vary in color and form.

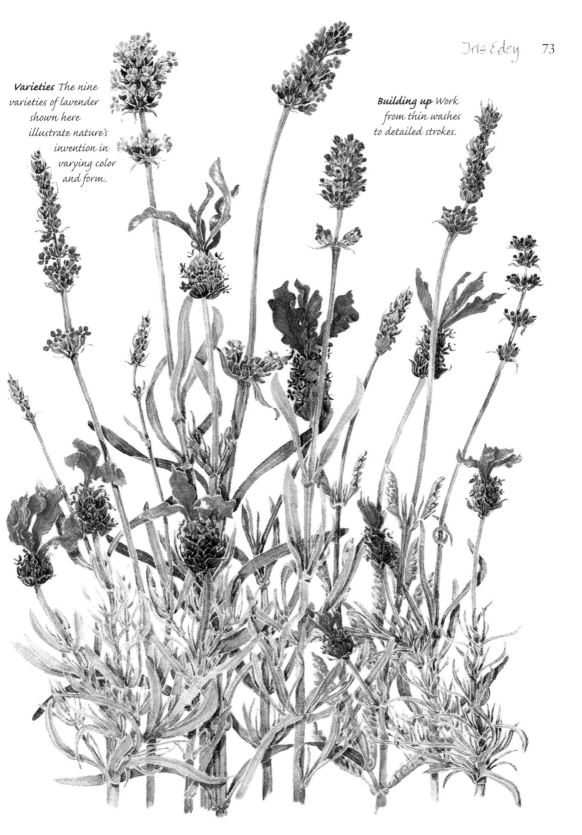

Varieties *The nine varieties of lavender shown here illustrate nature's invention in varying color and form.*

Building up *Work from thin washes to detailed strokes.*

MIXING YOUR MEDIUMS *A sketchbook page can feature a mixture of subjects and mediums, which combine to make sublime compositions.*

Form and depth
A confused climber is given form and depth by observing and drawing the overlapping stems.

Clean colors
Keep the palette and colors as clean as possible.

Values *A color wheel was created for this painting and then three values of each hue mixed on the palette. You can see the three values used on these yellow petals.*

Wayside flowers The composition of this posy cleverly conveys a sense of the wildness of the flowers.

The whole truth Stems are faithfully represented in the distorted shapes in which they have been found.

FROM SKETCH TO PAINTING
The artist transfers her completed ink sketches to tracing paper and stores them. A new painting starts with selection from her archives and assembly into a satisfying composition.

Transfer sketches
When the composition is right, the tracing can be transferred to an illustration board as a detailed pencil drawing, ready for painting.

Buildup of color
Here you can see stages in the buildup of color, from early wash, (center), to a buildup of strength, (left and right).

Piecing together traced sketches Using traced sketches, you can make an artificial grouping of plant elements, as if they had grown together.

Fine details Veins on petals add greatly to the shape of the plant and must be painted with care. A large (10 or 12), good-quality, pointed round brush will carry enough paint for this.

" The abstract qualities of flowers are what excite and fascinate me. I like to design with shapes and patterns, to wallow in their luxuriant colors and be stimulated by their textures and markings.

Ann Blockley

Interpreting flowers

Edge values are important in my paintings. Hard edges bring subjects forward into focus, and softer values sink into the background. However, this functional role is almost secondary. It is the emotional response to visual contrasts that I enjoy, such as a crisp line against a blurred or ragged mark.

BACKGROUND ROLES

I use backgrounds to create atmosphere and to complete the storytelling behind the flowers. The main subject is often depicted with a degree of detail and accuracy. The backgrounds, however, are largely drawn from imagination using loose and painterly watercolor.

I take into account the nature or habitat of the flower when I plan my finished paintings. A woodland bloom could be depicted against a dark and mysterious backdrop. A hedgerow plant, on the other hand, may have a decorative background employing the graphic geometry of intertwined stems and overlapping leaves. My meadow flowers are shown among textured washes, lively, bright, and scattered

SPLASHY MARKS *The artist uses the wrong end of the brush to drag splashes of watercolor into swirls and curls inspired by the shapes and patterns within the tulips.*

with broken, sketchy lines and flurries of dots.
Such texture seems to evoke a sense of
movement: the sway of stems or the flutter of
petals perhaps.

I am not interested in painting precise
representations of the subject. Instead I prefer
to interpret and suggest. Some of the marks are
left deliberately vague and unexplained, even
crude. However, placed in the context of
more literal painting, these abstract areas
take on meaning, and assumptions can
usually be made as to their identity. I enjoy
this slight ambiguity and mystery. **"**

VARIEGATED WASHES
*Washes of cobalt blue, cobalt
violet, and green gold have been
allowed to flow over the page.
With the first wash still
damp, pieces of plastic
wrap were laid down to
disturb the paint and
create crumpled
textures. Once dry, the
plastic wrap was
peeled away. The
artist then painted
into these marks to
suggest the shapes of
petals and leaves.*

Favorite colors

FRENCH ULTRAMARINE
COBALT BLUE
INDIAN YELLOW
PURPLE MADDER
GREEN GOLD
COBALT VIOLET
PERMANENT ROSE
QUINACRIDONE GOLD
PERMANENT MAGENTA
BROWN MADDER

CAPTURING WHITE FLOWERS
Painting the backgrounds of
these hellebores helped to
describe the flowers.

Background wash
STAGE 1: Paint a variegated
wash around the shape of the
hellebore, leaving the white
paper to describe the flower. Use
masking fluid to block out the
center and stamens.

Build it up
STAGE 2: Continue building up the background
washes and lift off the stem with a clean, wet brush.
The mask from the central area
can be removed once the
shadow washes over
the flower center
have dried.

Adding contrast French
ultramarine, green gold,
purple madder, and sepia
were sketched around the
flower shapes,
allowing all the colors
to flow together. Crisp,
colorful, straight-edged
stems and leaves
contrast with the
curves of the simple
white flowers.

Creating focus The main flower is kept hard edged and is largely white paper with a minimum of shading. Note how the edge is "lost" and "found" to create interest. The second flower is softer edged and therefore merges into the background.

Spattered details The flower centers were spattered on using the tip of a palette knife to create dots of color.

STARGAZER LILIES
A variety of contrasting hard and soft edge values are used to emphasize flowers or blur them into the washed background. These washes of color have been broken up with splashes and spatterings of water or paint to echo the blots and dots on the decorative lily petals.

Background colors

STAGE 1: Paint liquid
mixes of brown
madder,
quinacridone
gold, French
ultramarine,
and cobalt violet
around the lily shape.
Add the stamens.

Adding drama and texture

STAGE 2: With the paint still
damp, blur the edges
with a wet brush
and allow a
little of the
background
color to flow
into the flower
itself. Dribble in
dilute cobalt violet
and allow to dry in
mottled or marbled textures.
Form and detail can be added
with more precise marks.

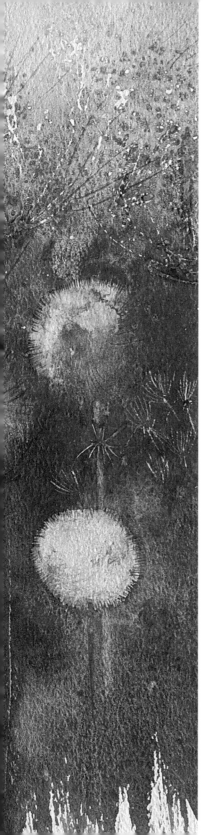

DANDELION CLOCKS

Before starting the finished work, the artist tried various methods and experiments to find the best way to express the pale, soft, feathery seedheads against a darker background. Salt was used in a wet background to create a mottled texture. White gouache was used on top of dry watercolor to emphasize parts of the dandelion.

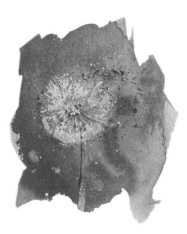

Creating granulated effects French ultramarine granulated into textured paper gives a lively background charged with the potential movement of exploding seedheads. Paint was kept dark and moody to convey a romantic impression of twilight. Pale circles were blotted out of the damp paint to begin the shapes of the clocks.

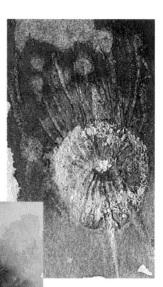

Detail The detail, (right), shows clearly how paint was scratched away to reveal lines of white paper that describe floating feathery seeds and also the first impressions of the cow-parsley behind.

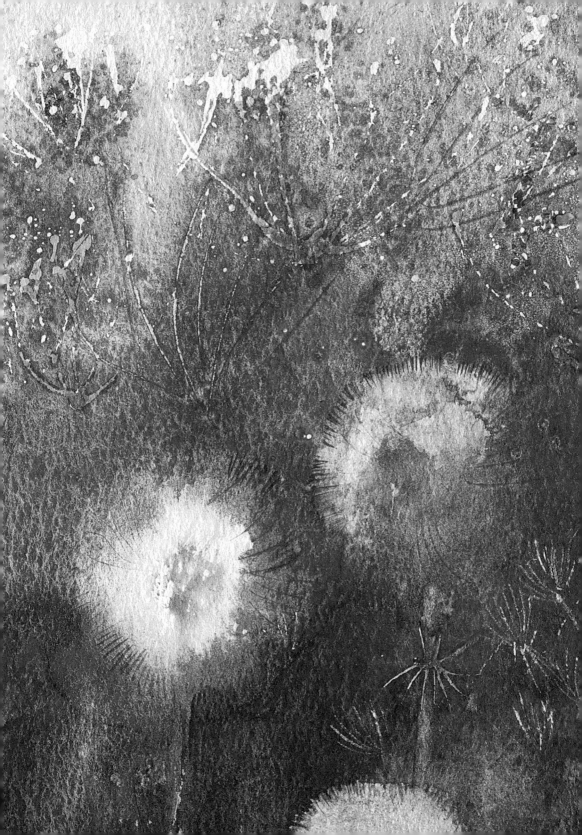

RICH COMPOSITION
On an excursion, vivid Mediterranean flowers are captured in quick sketches. First the strongest color is applied thickly, with the minimum amount of water. When dry, clean water is used to wash the color into the lighter areas.

Freda Cox

❝The novelty of pressing flowers—the very first primroses and violets, early purple orchids, heather, and harebells in summer—soon paled when they faded to a uniform brown. Then I discovered that painting was a far superior method of keeping records. My first efforts were ridiculed by an aged art master who admonished me for not looking at what I was drawing. I was eight, he was right. When I did look, I realized the leaves of bluebells did not start halfway up the stem! From then on it was a process of careful observation and a growing passion. Perhaps because of the first disappointment of that uniform brown, I now prefer strong, vibrant colors.

Favorite colors

SEPIA
DEEP CADMIUM YELLOW
VERMILLION HUE
SAP GREEN
FRENCH ULTRAMARINE
PURPLE MADDER
WINSOR VIOLET
PERMANENT MAGENTA
PERMANENT ROSE

Sketches for me are "memory hooks," acting as reference material for more detailed work later in the studio. They reflect careful observation, not only of the plant, but of the image as it flows across the page. I prefer working from live specimens so that I can feel the energy of the plant flowing through me. I like the idea that the painted image will survive long after its delicate petals have faded and fallen. My sketchbook drawings

Floral abundance on every page

are, of neccessity, very quick, in an effort to capture the flowers before the light changes or they wither.

Like other flower painters, my new passion overflowed into a love of gardening, another form of "painting with plants," and I grow many of the flowers I draw.

Personally, I prefer my detailed watercolor paintings, the more intricate the better—each petal, stamen, leaf, and stem accurately depicted. I rarely include backgrounds as this detracts from the botanical aspects. Others prefer my sketchbook drawings, which are freer. My dream is to paint exotic plants on a tropical island, lush vegetation not yet seen— before it's too late. What a delightful thing, this passion for plants! 99

IN ESSENCE *The artist aims to capture the essence of the plant by showing how it grows, moves, twists, and turns at all stages of growth. The pink trumpet vine, (above left), features buds, the fully opened trumpet-shaped flower, and the calyx after the flower has fallen.*

FLOWER RECORD

One of the artist's earliest flower notebooks, started during a visit to The Burren, Ireland, in an attempt to record and name the flowers of early summer. She managed 130.

Preferred paints The artist finds that tube watercolors used like oils, squeezed, not too wet, onto a palette, achieve a richer depth of color than pans.

Autumn's rich cornucopia Berries, seedheads, leaves, and twigs mixed with the last hedgerow flowers spread over the page. It may look like a matter of chance, but the composition of the page is constantly addressed with a balance of weight and color, and directional lines that lead the eye around the picture surface.

EXPRESSING ROUND FORMS

The artist uses overlapping circles of fine lines to create an impression of roundness.

Plotting the shape

STAGE 1: Salsify has large, soft seedheads, as big as a fist, which burst from a fat calyx. Having drawn in the stem and sepals, mark the center of each seed with a dot, plotting the shape of the seedhead.

Broken lines

STAGE 2: Suggest the individual stems radiating back to the main stem. Keep the hand relaxed and do not worry if the line is broken: it gives an impression of the fragility of the structure.

Perspective

STAGE 3: Finally, draw circles of fine lines radiating out from the center of each individual seedhead to form the "cobweb" effect of the whole. Note how these circles are seen in perspective and that the outer seeds appear as semicircles and ellipses when viewed from the side.

Color reference

Keep a color notebook recording a small sample of paint from each watercolor tube, with its name, make, and number, divided into color sections.

Salsify — Tragopogon porrifolius
Bluish-purple flowers which only open for a short period are followed by very large, seed heads with very delicate, feathery rays. Grass-like, linear leaves widen at the base and half clasp the stem. In flower April to June.

Color eccentricities Blues are difficult colors. They do
not reproduce well, even in watercolor. With blue paint,
you need to apply more water than normal since the
paint dries and will not wash back into highlights
in the normal way.

The art of seeing
Observation is of
paramount importance
with flower painting.
Notice how the leaf
wraps around the stem
in the yellow cabbage
thistle, emphasized by
darker shading.

WILDFLOWERS *All found on the same patch of ground in north Yorkshire, (from left, clockwise), lady's smock, speedwell, wild thyme, and goat's beard.*

Lizzie Harper

Closely observed flowers

"I adore drawing and painting flowers. It is my job but also my passion. I love creating an image on a piece of untouched paper, recording whatever plant is in front of me—usually in a jar of water. I love the mechanical side of it: putting a really sharp pencil to paper; the mixing of those gorgeous colors; repeating the same brushstroke time after time to create the furry texture of a leaf. It is easy to lose yourself in the networks of leaf margins and speckles, petals and veins, and I'm often surprised to find myself at my desk with a cold cup of tea and two hours gone. I can't imagine having a better job.

SKETCHES, NOTES, AND SPECIMENS

All of my favorite botanical studies are painted from life. Normally I study and sketch plants I've been commissioned to paint, closely examining a specimen to gather information before starting a final piece. First I do a pencil sketch of the whole thing, showing the shape and position of its leaves, flowers, and sometimes roots. Then, if I'm working on a study, I'll take a really good look at one of the leaves. Matching the greens is particularly tricky, and I try out various color combinations. I also study the way the light falls on the leaf, since that is the easiest way to show the pattern of the veins.

Moving on to the flower itself, you have to get the shape right and, again, the color. Color studies of buds are useful, too, since they can be surprisingly different from the open bloom. Written notes about color and shape end up on most pages of my sketchbook, often alongside a taped-in leaf or petal: these are not ideal for color reference, since they fade or brown, but they are helpful when it comes to reproducing shapes and leaf venation.

It surprises me how often people tell me, first, that they can't draw and, second, how jealous they are of those who can. In my view anyone can draw. Try to draw what you actually see, instead of what you think you see. Like any other skill, the more time you spend practicing the better you will become."

COLOR OF THYME
For the thyme flower the artist used alizarin crimson, purple lake, and a little white gouache.

Favorite colors

ULTRAMARINE BLUE	TAPESTRY YELLOW
YELLOW OCHER	CYCLAMEN
CRIMSON LAKE	ULTRA BLUE
PURPLE LAKE	

The last three are Dr. Martin's watercolor inks, used for intense glowing color.

Pale green, very folded,
brown edges
underside same pale colour as top –
glabrous

abaxial,
flowering stem
from within

– central
flower heads
age + go dk brown
before outer ones

stem slightly hairy

cream
not wht

ves
no felting below

as flowers age
these petals
→ ochre then
brown.
Individual flower
– v. light + minimal pappas

– flower head of
numerous flowers,
green-white colour,
star shaped
– buds in centre

older flower head

seed

**STUDY PAGE FOR A
FINISHED PAINTING.**
*The leaf of the
Japanese butterbur
matures later in the
year and will require
a second visit.
The artist uses a
hand magnifying
lens to study the
dissected flower.*

v. silky
pappas
achene

common ragwort

dker green, paler
twd stem

black tips (+ leaves)

Common ragwort For a
good bright yellow, use
cadmium yellow (dark)
more or less straight
from the tube. Keeping
one of the leaves is
useful as a reference for
shape and veins.

yellowish central
veins
greenish, but @
ochre

leaves amplexicaul

star like top
to each
disk flower,
base greenish,
florette tip cd yell

bud flushed @ green esp on corolla tube, greyish

Lesser periwinkle Getting the blue and mauve colors of this periwinkle right is tricky. The blue needs pink highlights (crimson) to get it looking like mauve. Crimson again is overlaid over the green stem.

Internalized stamen (Pl yell)

paler than lobes

corolla tube greenish at base, paler than lobes

flower stem + involucrae bracts not flushed @ crimson

Stem flushd with crimson, redder as you reach apex

X Sect

nca minor

CLEMATIS STUDY
These pencil sketches examine how light falls on the delicate petals. It is the way the shadows fall on the folds of the petal that give away the vulnerability of the flower. A hard H lead makes truly dark shadows difficult but it guarantees sharp lines and details.

Form These pencil drawings look at the flower's structure, and, below, how the petals are attached to the stem.

Leaf, bud, and stem These studies include the tracery of the leaf veins.

Color options
These flower sketches play with
color options. Outlined in silver,
the flower (top right) shows
a simplified version
with "leading" as if for a
stained-glass window.

Watercolor inks The artist uses
Dr. Martin's watercolor inks diluted
with water: cyclamen, ultra blue,
violet, and moss rose. White
gouache added to the ink changes
the hue.

Accentuation Shadows in blue
and purple keep the flowers
looking bright.

clematis

1 main pe
5 stame

Careful placement
The placing of each
element of a plant
requires concentration.
The artist here has
sorted out which trumpet
flowers of the composite
head are in the front
and which are behind
by shading some
and leaving the
others as line
drawings.

Honeysuckle study
The trumpet flowers
within each composite
head are at different
stages of development,
so there are lots of
different shapes and
colors, some budding and
others withering. The
structure is a miracle of plant
design with all the trumpets
radiating from a central point.

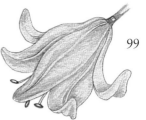

Diversity of shape
Depending on the angle
it is seen from, each
bloom has an
individual character
that has to
be recorded.

Perspective The stamens of
these lily flowers need to be
foreshortened to make them
come out toward you.

Velvety pollen The texture of the pollen on
the stamens, contrasting with the smooth
waxy petals, is achieved by layering colors:
cadmium yellow light, cadmium orange,
and alizarin crimson.

Focusing background The blue
background, (far right), focuses
the eye on the complex edge of
the petals without resorting to
darkening them.

THE ARTIST AT WORK

The wonders of nature

Lizzie Harper is a botanical illustrator who turns her hand to a multitude of drawing and painting jobs. One of the remarkable aspects of this artist is the speed with which she completes a detailed study such as the one here—the drawing and painting spill out of her. This requires accurate observation, but the results are anything but dry. Unlike most flower artists, the painting technique here does not involve layers of translucent paint but is executed quickly in one layer using relatively dry and concentrated mixes of paint and ink.

1 Initial drawing Holding the spray in her hand, close to the page, the artist sets about drawing the complicated flower head. Measurements are compared to get the length of the stem and the diameter of the flower head right. A sharp 2H pencil gives a clear contour line. Here some shading is added to the flower head to provide form.

2 simplifying detail The drawing contains all the information needed without recording every single detail. If you look closely, you will see that there are examples of the striations on the individual flowers, the hairs on the stem, and the darkening at the tip of the narrow leaves, but not in every case do these details occur.

3 completed drawing In the course of the drawing, one of the flowers has been taken to pieces so that the construction of the flower head can be clearly seen and the individual parts drawn as part of the study.

4 Finding the right green The artist laughs at her method of testing if the right green has been mixed: she tries it on the leaf itself. Avoid tube greens and try yellow ocher, cadmium yellow, indigo, and ultramarine as the base for greens, with browns or cerulean blue, or sometimes reds and purples too. Dr. Martin's inks are sometimes added for extra intensity. Unlike the usual advice, the artist plots the dark greens to start off, with the highlights left as white paper.

PALETTE

Watercolors

Yellow ocher

Cadmium yellow

Indigo

Ultramarine blue

*Cerulean blue

*Cobalt blue

Vandyke brown

Dr. Martin's inks

*Peacock blue

*Ultra blue

*Cyclamen

Grass green

Chartreuse

Gouache

White

Inks are added to the starred colors to keep them from sinking into the paper and to pump up the vibrancy of the hue.

The tips of the leaves are touched with Vandyke brown.

5 Mid-tones Mid-tones are created from the edges of the darks with added water. Some of the shading on the leaves comes from the pencil underneath but ridges are added with a fine, 000, round sable brush.

6 Subtle shades of green With the green part of the main spray finished, you can see the subtle changes in color used in the greens, leaning toward yellow ocher in parts and toward a fresher blue-green in others.

Note the attention to detail: tiny white flecks on the leaves added with white gouache.

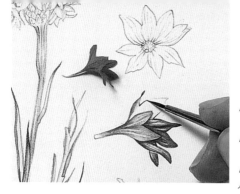

7 Tricky blues *Starting with the particular, this floweret can be used to try out color possibilities. Starred in the Palette, previous page, inks are added to watercolors to keep them from sinking in and to pump up the vibrancy of hue. First the artist paints around the edge where it is darkest. Then she paints around the highlighted petal ridges that will appear as white paper. Water is added with a clean brush to take paint away from mid-tone areas and blend the edges of each tonal area.*

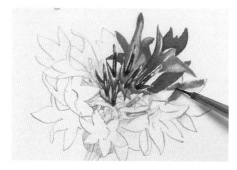

8 Light against dark, dark against light *So carefully observed, the bud with its overlapping platelets is painted with yellow ocher and cobalt blue, with touches of pinks and Vandyke brown. Note how the hairs on the dark bud are left as white, carefully painted around, while those seen against the light are painted in brown.*

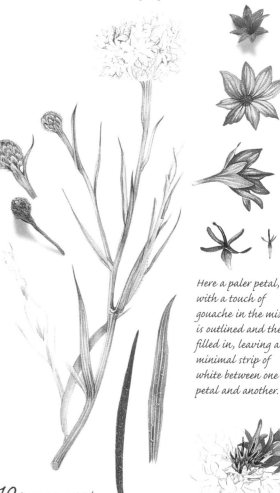

Here a paler petal, with a touch of gouache in the mix, is outlined and then filled in, leaving a minimal strip of white between one petal and another.

9 Individual blues *Mixes of blues and pinks, both ink and watercolor, are carefully chosen for individual petals of the flowerhead. Blues are affected by the light, with some petals darker and cooler in the shade, and others paler and warmer with the light shining through.*

10 Reassessment *The cornflower study is surrounded by its parts, magnified for easier study. Seen with the real parts of the flower, you can see the differences in scale and also the results of decisions made about color.*

11 Memory hooks The study sketch is complete. The artist has learned about the construction of this complicated bloom through drawing and then painting it. To help jog the memory at a later date, when this study sketch is used as a reference, notes are added. They cover all sorts of information, such as the date, colors used, physical details—"stem swells just below flower head"—and measurements. The artist often presses the flower, or parts of it, with her sketch to remind herself of shapes and textures rather than colors.

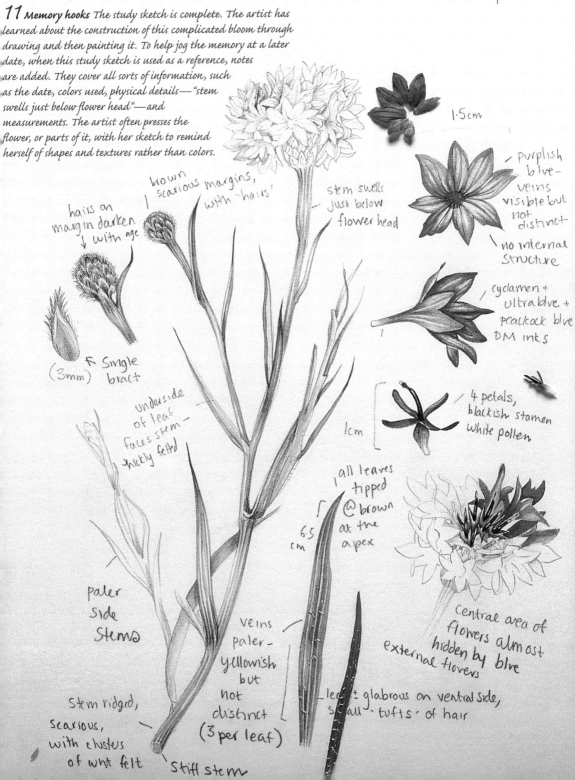

1.5cm

brown scarious margins, with 'hairs'

stem swells just below flower head

purplish blue - veins visible but not distinct -

no internal structure

cyclamen + ultrablve + peacock blue DM inks

hairs on margin darken with age

Single (3mm) bract

underside of leaf faces stem - thickly felt'd

1cm

4 petals, blackish stamen white pollen

paler side stems

all leaves tipped @ brown at the apex

6.5 cm

central area of flowers almost hidden by blue external flowers

veins paler - yellowish but not distinct (3 per leaf)

Stem ridged, scarious, with clusters of wht felt

leaf ± glabrous on ventral side, small 'tufts' of hair

Stiff stem

Olivia Petrides
Observing and recording nature

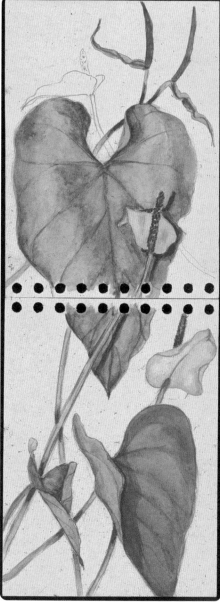

"My interest in the natural world comes from my parents. My father is a wildlife ecologist and botanist who has worked around the world, often taking us with him for years or months at a time. Since 1990, he and I have worked together on field guides to trees. We have done seven field manuals, two in the classic *Peterson Field Guide* series. My mother is an incredible gardener, who has worked on community, state, and national levels promoting horticulture. She has tended and expanded her own garden for fifty years. When I visit, the first thing we do is walk through her garden. My mother ritualistically names each plant, detailing where she got it from or who gave it to her. Even though I know the garden by heart, I love this ritual.

SPENDING TIME SKETCHING
My sketchbooks are working documents and reference sources that I take into my studio. They are the basic element of my painting practice, both as a botanical illustrator and as a landscape painter. I work in my sketchbooks outdoors, often in remote areas. Unlike taking photographs, painting on site means spending time in a place and observing it closely. I also become aware of the other sensory aspects of the setting, such as sounds, smells, and weather changes. I jot down

ELONGATED SPACE
Working across the gutter of a sketchbook offers a new format, so this climbing philodendron could be followed upward.

DIFFERENT VIEWS *Views of the pitcher plant, (below) painted in the Chicago Botanic Garden, help to piece together its unusual structures.*

WET STUDIES *The pussy willow (far right) and allium (right) were painted in Iceland in May. A waterproof poncho and a thermos of coffee were useful items of equipment.*

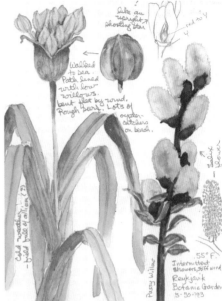

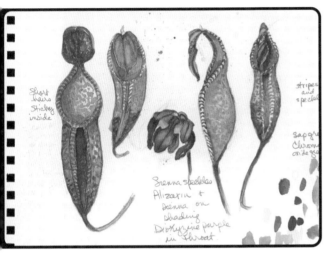

COMPOSITION *Composing the indigobush, (below), for identification purposes means making the alternate branching pattern evident so it could be seen that the leaves are lighter underneath.*

Favorite colors

SAP GREEN
ULTRAMARINE BLUE
ALIZARIN CRIMSON
CADMIUM ORANGE
LEMON YELLOW
RAW UMBER
VANDYKE BROWN

these observations, as well as random thoughts and color mixtures.

When I am sketching a flower, I respond first to the sculptural shape of the subject. In pencil, I sketch the general shape, noting with line weight or shading the push and pull of the flower within the space around it. I look for structural geometry. Then I measure it, comparing lengths, widths, and angles of parts to each other. When the parts are placed correctly in the space, I add details of form and surface patterns. I like to emphasize what is peculiar to the particular plant, such as holes, tears, or unusual growth habit. 〞

VISUAL COLLECTIONS

The artist keeps extensive sketchbooks when traveling, making a visual collection of plants, but also of rocks, birds, architectural motifs, signs, and labels—whatever piques her interest.

Contrasts in shape The bulbous curves of the bodies of the pitcher plants seen against the vertical lines of the flower stems give some tension to this composition.

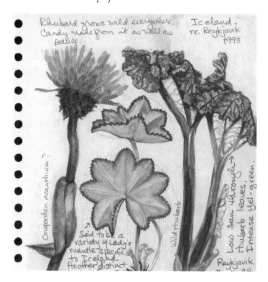

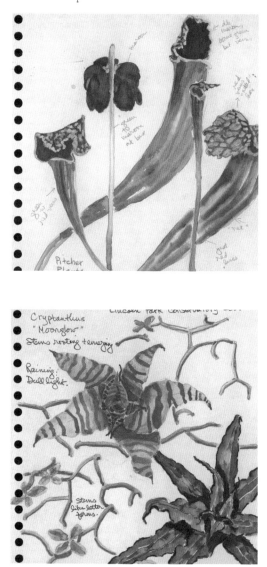

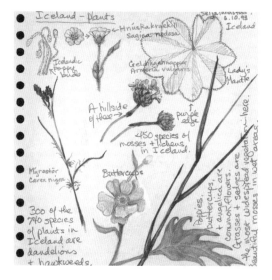

Icelandic flora These sketches mix the use of pencil, colored pencil, and watercolor.

Floral calligraphy The artist was drawn to the leaf of this cryptanthus. The leaf shapes and linear patterns of the rootlets flow through the space of this sheet, more like a page of calligraphy than a painting.

Visual contrasts Orchids embody strong visual contrasts: the leaves are simple, leathery, and functional; the blossoms extravagant, bold, and wildly colored; and the roots pale and delicate.

White highlights The white of the paper is reserved for the glossy surface of the leaves.

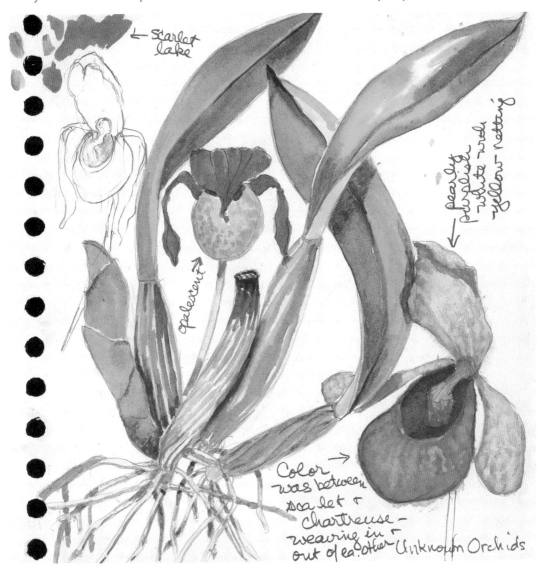

Scarlet lake

opalescent

pearly purplish white wal yellow netting

Color was between scarlet & Chartreuse— weaving in & out of ea. other Unknown Orchids

Darks An undercoat of red—green is complementary—is present in the darkest areas of the leaves.

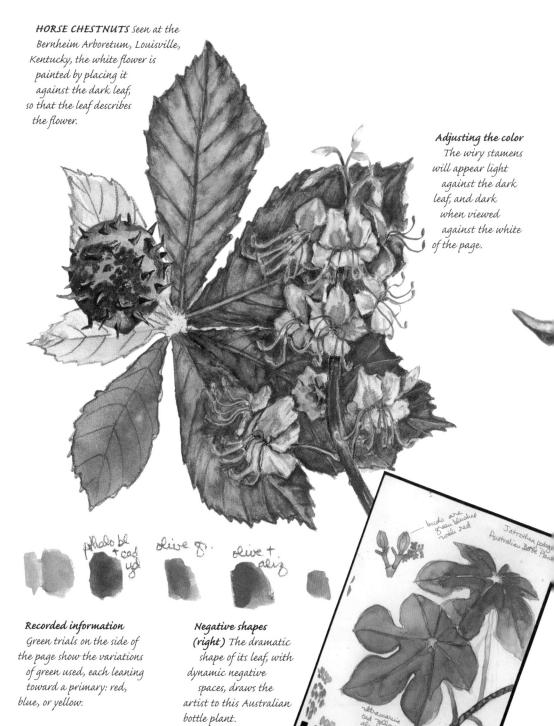

HORSE CHESTNUTS *Seen at the Bernheim Arboretum, Louisville, Kentucky, the white flower is painted by placing it against the dark leaf, so that the leaf describes the flower.*

Adjusting the color
The wiry stamens will appear light against the dark leaf, and dark when viewed against the white of the page.

Recorded information
Green trials on the side of the page show the variations of green used, each leaning toward a primary: red, blue, or yellow.

Negative shapes
(right) *The dramatic shape of its leaf, with dynamic negative spaces, draws the artist to this Australian bottle plant.*

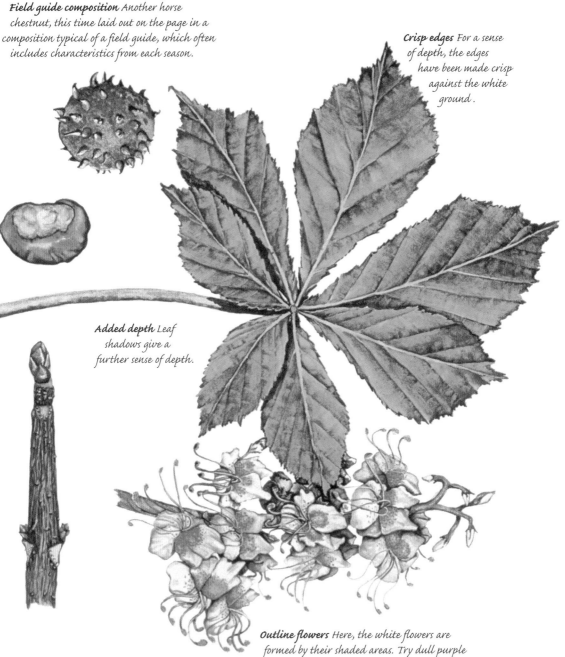

Field guide composition *Another horse chestnut, this time laid out on the page in a composition typical of a field guide, which often includes characteristics from each season.*

Crisp edges *For a sense of depth, the edges have been made crisp against the white ground .*

Added depth *Leaf shadows give a further sense of depth.*

Outline flowers *Here, the white flowers are formed by their shaded areas. Try dull purple and light green tints for the shadows and lightly outline the flower, which would otherwise disappear. The interiors of the petals are bright pink and help define the flower shapes.*

" My love of flowers has been with me all my life, but as an artist my journey of experience has traveled through all mediums and subject matter, slowly evolving within me.

I decided about twenty years ago that I would specialize and focus exclusively on flower painting.

Carole Andrews

Painting flowers: life and light

Flowers, with their great gift of beauty and amazing intricacy and variation of form, epitomize to me the wonder of the true life force of nature; yet they still retain an honest, beguiling simplicity. So how do you capture this in paint?

Watercolor is my preferred choice because of its purity and delicacy. I try to work with transparent colors wherever possible, and glaze again and again with different hues to create the depth of form and evoke three dimensions. I love to work wet into wet, to avoid the hard image, allowing the white of the paper to shine through for light and emotion, and striving all the time to express the life force of the flower for all to see and feel.

ARTISTIC APPROACH

Each painting is very carefully thought out, but the initial composition is inspired by the beauty of a single flower and a contrast of shape, form, or texture—something that captures my imagination.

I always start with the focal point, perhaps the flower from a tree peony, an iris, a rose, whatever inspires me in the garden. The rest of the painting is then composed around that central idea. Other flowers, berries, fruits, or household objects, such as cups and saucers and

Favorite colors

TRANSPARENT YELLOW
AUREOLIN YELLOW
COBALT BLUE
PERMANENT ROSE
QUINACRIDONE MAGENTA
QUINACRIDONE RED
TERRE VERTE

LINE DRAWING *A fine line drawing was produced before painting this iris bud.*

small pots, are included, but each addition complements the original. The painting becomes a meditation as the flowers convey the essence of the life within.

The paintings are completed with either a soft background wash, picking up the light and shadows to enhance the flower, or, for a more powerful image, strong colors are dropped into very wet washes, allowing the beauty of the colors to blend.

When my paintings are complete, my wish is that those who look upon the work will experience with me all the wonder and the beauty of the actual, living flowers. **"**

CAPTURING THE MOMENT *The artist was captivated by this rose and honeysuckle combination. The focal rose was drawn first and the rest of the elements relate to it. Glazes and blended colors bring a feeling of light and life.*

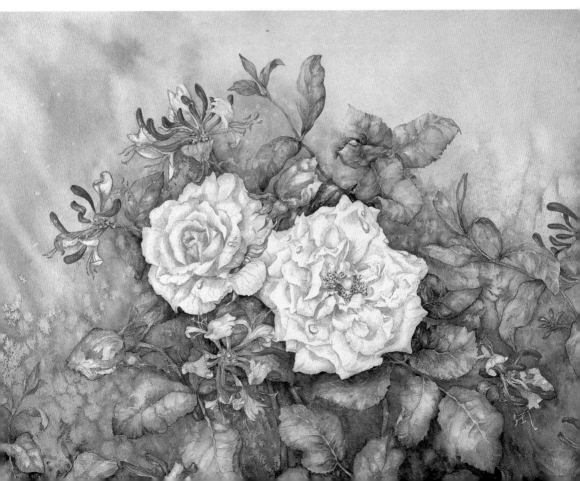

Highlights
The petal
highlights
are left as
white paper.

VIBRANCY OF YELLOW

With yellow flowers such as daffodils,
keeping the yellow pure and yet strong
is a challenge. It has been achieved
here by painting in the shadows first
and then glazing over them with
pure yellows (see demonstration,
pages 116-119).

Pencil work For yellows, use as little
pencil work as possible since it will show
through the paint and purity can be
lost. Pencil marks are difficult to
remove after water or color has been
applied. Here you can see what happens
with too much pencil.

Depth of tone
Laying in
shadow colors,
first, then
adding
successive glazes
of yellows,
builds up a
depth of tone.

Testers *Try out colors on the edge of your paper before committing them to your painting.*

Finding colors *This daffodil had a noticeable green tinge to it, so a final glaze of viridian and aureolin yellow was touched over parts of the petals.*

Natural movement *Daffodil leaves twirl and twist, enabling you to create movement in your painting.*

Color mixing *Indigo, transparent yellow, and cobalt blue have been used for the leaves, and for the dying leaf, new gamboge, raw sienna, light red, and cobalt blue.*

Thorough study *Every part of the daffodil is looked at carefully so that the information can be used in a finished painting.*

Highlighting edges The delicate frilled
edges of these cyclamen petals are
exaggerated by leaving a thin line of
reserved white paper along the borders.

**Building up the
color** The color is
strengthened and
deepened with each
successive wash.

"Found" edge This expressive petal
with its "found" edge shows up
well against the dark of the leaf.

Leaf markings After a careful
drawing, paint the leaf section by
section, using the veins to divide it up.
Add washes wet into wet, moving the
paint with a clean brush, leaving the
veins and special markings as white
paper. Add an uneven pale green wash
over the veins when dry.

Glorious underside Permanent
magenta and cobalt violet are
dropped wet into wet into a
soft green of watery viridian
and aureolin yellow.

Frilly edges The frilly edge here is expressed another way by showing a paler foreground petal against a darker one behind. Lay in pale washes over the whole area wet into wet and then work with stronger, darker colors around the lighter petal, wet on dry.

Pinks Here the artist used permanent magenta and permanent rose.

Finishing touches Glazing over the reserved white of the leaf patterns and veins with a pale watery green wash dulls the contrasts and pulls the leaf together.

Background colors Colors used in the flower and leaf (cobalt blue, aureolin yellow, and cobalt violet) were allowed to run together, wet into wet, for the background, coming in around the bottom of the leaf.

THE ARTIST AT WORK

Working with yellows

Carole Andrews is impassioned by flowers
and is a trained botanical illustrator. But her
paintings go beyond scientific study, as she aims to
capture the life force of the flowers. In this painting of a
daffodil, based on information she has gathered in numerous studies
of the flower, she tackles the tricky problem of creating shadows on a
yellow flower without muddying the glories of the transparent hue.

1 character drawing In the drawing, the artist aims to record not just the botanical structure of the bloom but also the character, trying to capture the flower as it might appear in the garden, stirred by a breeze. A pencil with a 0.3 HB lead will give a clear but not too dark line.

2 shadows for the yellows To stop the dark yellows from muddying, shadows are painted in as a first layer using two mixes, one warm (blue) and one cool (green). The blue shadow wash is painted on a wetted surface and blended into the background at the edges. A cooler green wash is added to the petal center and blended at the edges into the blue.

3 "Wizzling" brush Now to start on the flower head itself. The artist works with three brushes in her left hand, as well as a tissue, and one in her right. They include "blue" and "green" shadow brushes and a self-termed "wizzling" brush to soften hard edges, move the paint, and blend it once laid down, drying it off when necessary with the tissue.

4 Finishing the under painting The shadow layer of the daffodil proceeds with blue shadows in the darkest parts, green for the mid-tones, and with the white paper left for the highlights. Note how the deepest shadow in the depth of the trumpet throws up the frilled edge and the stamens.

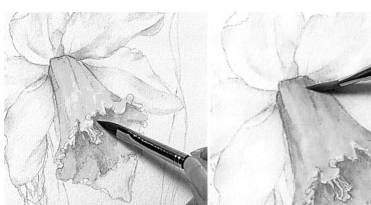

PALETTE

T TRANSPARENT O OPAQUE

Shadow washes for flower

BLUE (WARM):

cobalt blue (T),

cobalt violet (T), and

Davy's gray

GREEN (COOL):

terre verte

Yellow flower

Transparent yellow (T)

New gamboge (T)

Cadmium orange (O)

Scarlet lake

Husk

Viridian (T)

Aureolin yellow (T)

Raw sienna

Light red

Cobalt blue (T)

Winsor violet (T)

Leaves

LIGHT TONE:

viridian (T) and

aureolin yellow (T)

MID-TONE:

cobalt blue (T) and

aureolin yellow (T)

DARK TONE:

indanthrene blue (T) and

transparent yellow (T)

Shadow wash

Cobalt blue (T)

Permanent rose (T)

Terre verte

Naples yellow (O)

5 **Transparent yellow glazes** *Once dry, the next step is to glaze over the shadows with transparent washes of yellow. Start with the palest transparent yellow; reserving the white paper for highlights. Work on one area at a time, here the trumpet, brushing it with water first and then adding the color straight from the pan. While still damp, add new gamboge yellow in the shadows. Then, for the depths of reflected yellow; add cadmium orange and a little scarlet lake to brighten it up.*

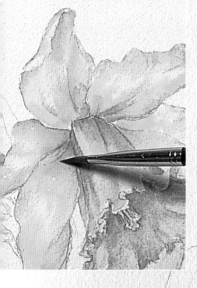

6 **Outer petals** *Now paint the outer petals, one at a time. Reserve highlights still as white paper but blend any hard edges with the "wizzling" brush.*

7 **Finished flower** *The flower head is complete and the yellows positively glow. Tonal gradations have been achieved without muddying the purity of the yellows used.*

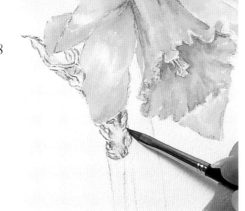

8 Linear marks Next comes the papery husk —the sepals. First use yellow-green underwashes of viridian and aureolin yellow; then a bright fresh green for richness. Once these are dry, graphic linear marks of raw sienna, light red, and cobalt blue made with the point of the brush express the brittle fragility of the husk.

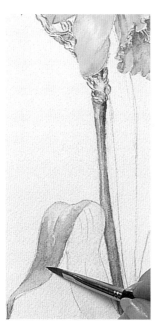

9 Reflective leaves The palest of three green tones (see Palette, page 117) is fed onto wet paper first. This yellow-green is the reflection of the daffodils around. Next the mid-green and then the darkest tones are added. The stem and the left-hand leaf are generally a more mature and yellow green. Note the touch of pure yellow on the stem on the swelling below the husk. The leaf greens are built up slowly, wet into wet, working on the three-dimensional aspect of the leaves and bearing in mind that the direction of the light is from above and behind the stem.

10 Brighter green The right-hand leaf is fresher and bluer. Adjust the mixes suggested on page 117 to take account of this. The bright green wash is added and melded with the first paler one with the "wizzling" brush. Very restrained, dryer, more graphic brushstrokes suggest ridges and veins and emphasize the characteristic tips.

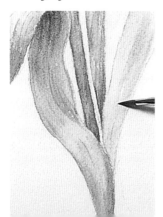

11 shadow wash The greens have been further built up and a final dilute wash of cobalt blue is run over the white highlights to suggest a reflection of the blue sky above. Now a shadow wash around the base of the flower marries it to the paper. Cobalt blue and permanent rose are added to the wetted paper, and Naples yellow is "wizzled" in.

PENCIL DRAWING *Smooth, clear contour lines delineate the individual petals of the amaryllis and the graceful arch of the two stems. It is critical to define the pistils and stamens. Try starting with these central elements; the petals then seem to fall into place around them. The drawing is the structure of the painting, not an end in itself.*

Sally Robertson

The art of the contour line

" My artistic career really began when I moved to a rural coastal area just north of San Francisco, and began work on my garden, which has become a destination in itself. I am often asked which came first, and I must reply that, in truth, both the garden and my painting have evolved together.

I spent many years as an art dealer and I was especially drawn to the sumptuous pieces of the art nouveau period. Parallels to this movement can be seen in my own work, which was first inspired by the native coastal iris. I tend to seek out the naturally ornamental and elegant linear aspects of my subjects and, in the iris blooms and the lovely whiplash curves of dying leaves, I found strong echoes of those turn-of-the-century aesthetics. I continue to be inspired every year by the delicacy and grace of the native iris, and the rich colors of the hybrid versions of the same plant.

LINE AND COLOR

Line work and drawing are critical elements in my work. The choices I make before even beginning to draw are all important, too, searching out the most graceful curve or telling point of view. I begin drawing from the center of a flower and work outward, often looking directly into the bloom. If a flower has

PACIFIC COAST IRIS *The artist painted the petals behind first, letting them dry before going on; this slight overlap helps create the illusion of depth. The large outer petals are washed with yellows, stronger in the center. The intense purple is allowed to flow into a transparent wash.*

an intricate pattern of stamens, then that is where I begin, depicting the tracery of filaments as they arch and intersect; the petals then fall into place naturally around them.

While line and drawing are the backbone of my work, I have a reverence for the magic of watercolor. I never use pigment directly from the tube, but experiment with color mixes. I always work wet into wet, within defined areas, and take great pleasure in watching the pigment react as it hits the water. Close observation combined with a joy in the spontaneous poetry of watercolor and a faith in its intrinsic power to reflect nature is what guides my vision. 99

Favorite colors

CERULEAN BLUE
COBALT BLUE
COBALT TURQUOISE LIGHT
QUINACRIDONE MAGENTA
ROSE MADDER GENUINE
WINSOR YELLOW
NEW GAMBOGE
QUINACRIDONE RED

Sculpting flowers
Interior contours
give form to the
flower, and cast
shadows add
definition.

MAGIC OF WHITE
The first rule for painting
white flowers is that the
purest white is the white of
the paper. Search out the
contours, both interior and
exterior, and hints of color in
the white, whether local or
reflective, "sculpting" the
flowers in two dimensions
out of the flat white paper.

"Found" edge If the edge of a petal is
pure white against a white
background, tint up to it from the
outside using a soft gray, so the pencil
line disappears. Use water to blend
the pigment into the white
background. Mix these gray tones
from chalky colors such as Winsor
emerald and cobalt violet, or cerulean
blue with a touch of vermillion. Add
cobalt turquoise light for sparkle and
lemon yellow for warmth.

Contour tinting Brush
a stroke of water near
a contour line, apply
intense pigment up to
the line, and add clear
water to dissolve the
pigment into the white
of the paper.

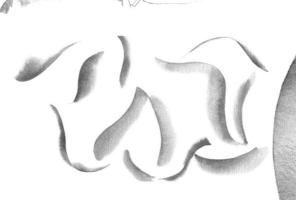

Rainbow of light
Use clear colors:
Winsor yellow in the
center, Winsor blue at
one end, and permanent
rose at the other.
Carefully blend into a
rainbow on the edge
of a petal.

Colored shadows *The soft whites of the gladiolus petals are fused with subtle glowing color: a hint of lemon yellow suggests sunlight; an aqua tint reflects a nearby green; and a blue-purple indicates deeper shadows.*

AMARYLLIS

The belladonna lily blooms freely every summer, after its leathery green leaves die back. Another of its common names, "naked ladies," needs no explanation.

Paint and pencil
The pencil line is still visible through the painted layers, holding the composition together.

Pairing flowers (opposite page) The smoky maroon stems of the amaryllis contrast with the delicate pink of their flowers, with the white blooms of the agapanthus providing the opportunity to play on a negative/positive concept.
The deep colors of the amaryllis stems and flowing washes in the background give definition to the small white flowers.

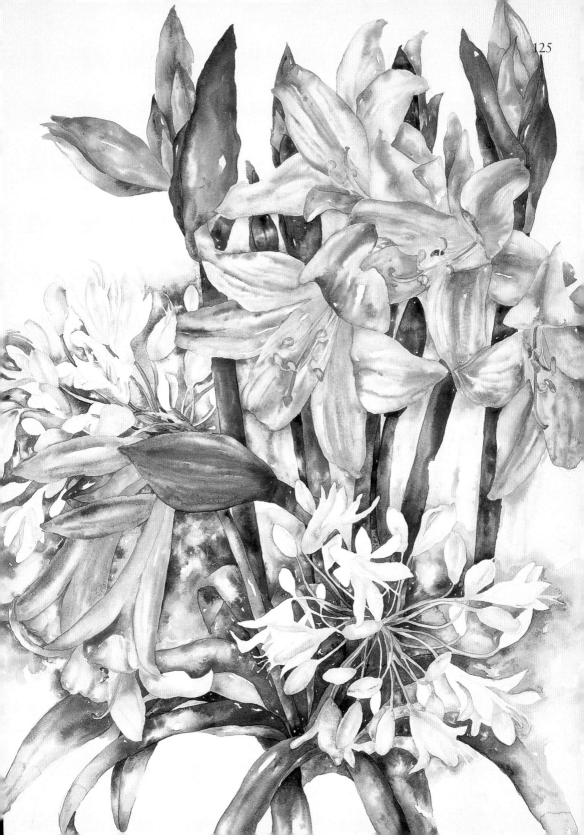

Drawing design The line work follows the design of the form, so that the lines expressing the pale flowers in the center are as intrinsic to the drawing as those of the more finished blossoms.

Negative spaces Although the strong pencil lines depict the flowers and stems, elegant negative spaces are equally important. The cymbidium orchid in this sketch, with its graceful arching sprays of blooms, is almost a study of the art nouveau.

CREATING EDGES

The edges of the orchid petals are sometimes highlighted with a white border, sometimes held by the underlying pencil drawing, and sometimes "found" with a wash of neutral color.

Framing petals

Stage 1: Start with a contour drawing, then paint those areas furthest back. Try rose madder genuine, quinacridone magenta, cobalt violet, and alizarin crimson for strength in the line work, and cobalt blue where darkening is needed.

Finding edges

Stage 2: Once dry, move on to the next petal. Place the light edge of one petal against the dark edge of its neighbor, or divide them with a white border, particularly distinctive to this orchid.

Defining background washes

Stage 3: Having completed the flower, define those edges with white borders with neutral tints in the background, using Winsor emerald and cobalt violet with a touch of cerulean blue, for example. Now wash over cast shadows.

A painting in every petal *The distinct rose and yellow tones are applied wet into wet, defining the individual curves of every flower.*

Graphic design elements
The arch of the stem and the overlapping of buds form a natural pattern here. Flowers seen drooping to the side offer a graceful graphic touch. Maroon markings on the lips add to the graphic detail that holds the composition together.

Organic forms wet into wet Apply a stroke of water with a loose gesture, not meticulously up to the edge, then touch in the color mixture and enjoy watching it expand and react as it hits the water. Guide the pigment precisely up to the pencil line, so it virtually disappears, being careful and distinct at the edge.

Mini color chart For the iris the artist used: cool colors, (left): cobalt turquoise light, cerulean blue, cobalt blue, and Winsor blue (green shade); and warm colors, (top): permanent rose, quinacridone magenta, alizarin crimson, and cobalt violet. Mix equal amounts of the blue hues and the rose for an amazing range of colors.

CALIFORNIA NATIVE IRIS *Note the range of purples on each petal, deepening toward the center.*

Natural design element *Iris clumps are punctuated by the wild curving arches of the dry leaves, casting shadows across the green blades.*

Lighter tones *Define linear aspects with lighter cerulean and turquoise tones, added while the petal is still fairly wet.*

PANSY SKETCH *A sketch of the structure and color variety in the flowers, buds, and leaves will be used in constructing one of the artist's monumental, abstracted flower paintings.*

Ann Smith

Exuberance of scale

66 Growing up in Southern California, I was surrounded by flowers, and every family vacation I was given a new box of crayons and a thick sketchpad. Both of my parents honored their own creativity and encouraged mine. One of my most magical childhood memories is of being carried outdoors in the middle of the night to witness the rare and beautiful floral display of a majestic night-blooming cereus. The valuable gift of taking time to nurture inspiration was shared with me that night.

In 1965 I earned my college degree in Biological Illustration from University of California—Los Angeles. For some time I worked hard producing scientifically accurate illustrations for biology journals. I am very grateful to have had such specialized art training, but I found I desperately longed for more artistic autonomy. While raising my children I rediscovered the joy and spontaneity of watercolor and the therapeutic pleasure of painting. Today my free-flowing abstract flower paintings bear little resemblance to the illustrations I turned out forty years ago.

Favorite colors

COBALT BLUE
FRENCH ULTRAMARINE
WINSOR BLUE
ALIZARIN CRIMSON
ROSE MADDER GENUINE
BURNT SIENNA
HANSA YELLOW
AUREOLIN YELLOW

DRAWING AND PAINTING

Drawing and painting are two completely separate experiences for me. They each seem to satisfy a different appetite and I crave them both. Drawing is a careful information-gathering process that becomes deeply internalized. Once drawn, a flower is forever in my memory bank.

Although most of my large floral paintings do not begin with a plan, all of them are rooted in my mind's storehouse of sketched images. Whereas my drawings are done as a controlled intellectual discipline, the painting experience can feel wildly emotional and expressive. My most exciting paintings are those that slowly evolve as a discovered image. 99

TINY SKETCH
Shown at actual size, this sketch is packed with information.

MONUMENTAL PANSY PAINTING
In this vast 6 ft (1.8m) by 4ft (1.2m) watercolor the artist takes her lead from the colliding of pigments. Flower structure is suggested and color authenticity is subordinate to gesture and feeling.

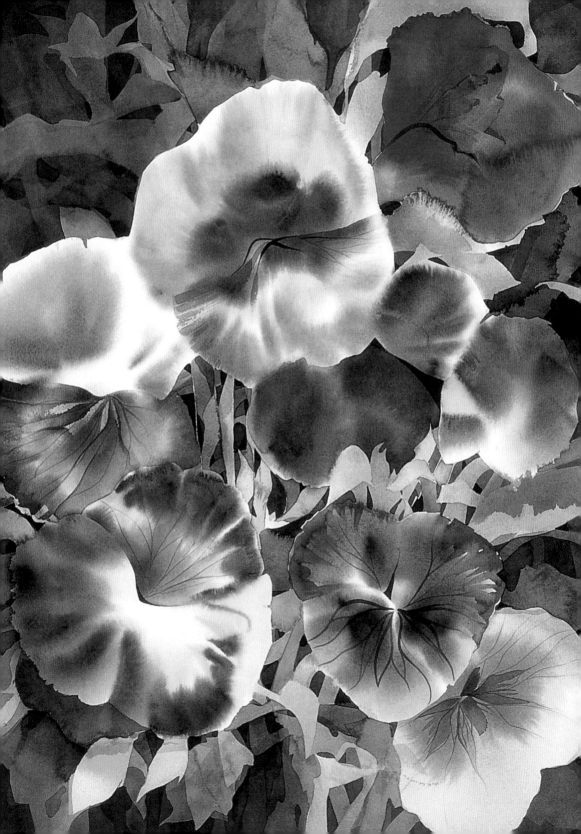

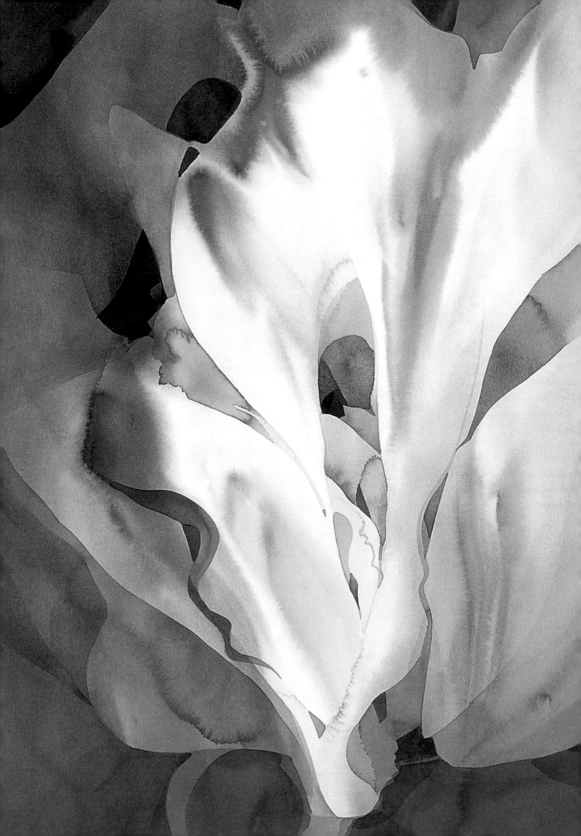

Careful study The artist's large abstracted paintings develop from the careful study of plants. Here two dried proteus plants are painted in detail. Each brushstroke is considered in relation to every other brushstroke and careful decisions are made each time the paper is touched.

Choices
Decisions of shape, size, color, direction, value, and texture exist for each petal leaf and stem.

Colored neutrals The dried petals are painted in colored neutrals leaning toward primary colors: red, blue, and yellow.

Suggested form
Even in such careful studies, elements of suggestion and simplification are necessary, as in the flower center where a melding of color is superimposed with spattered dots.

Abstracted forms (left) Loose washes of Hansa yellow, alizarin crimson, Antwerp blue, and Winsor blue were flowed onto a full sheet of Arches 140 lb (300 gsm) cold-pressed paper and allowed to dry before sections were rewetted and more color and hard-edged shapes added. A feeling of transparency and lightness gradually emerges from repeated layering and negative space painting.

Spatial awareness
Overlapping leaves express the spatial depth of the plant.

"Thirsty" brush Early washes are controlled with a "thirsty" brush, a dry brush which soaks up surges of wet paint.

Expressive striations Markings can be made by dragging the brush handle from one area of dark wet paint into a lighter area.

Controlling edges Soft edges are painted wet into wet; hard edges, wet on dry.

Learning from sketching This small watercolor study of a bird-of-paradise in full bloom taught the artist that shape, line, and color are the most important aspects to emphasize in interpreting this flower.

Colors Early sketches help to identify colors for later, large-scale paintings.

Large-stroke painting (above) Painted on dripping wet watercolor paper, working quickly but deliberately, the overall design pleased the artist enough that she let it stand alone against the white background. Soft edges and bleeding saturated color give it an emotionally expressive energy.

Further abstraction (right) This image is a dramatic and mysterious blend of tight control and abandon, all in the same painting. After "sloshing" on lots of bright pigment, the slow, searching process of layering on infinite form-defining glazes begins. Fresh areas against muddy ones, soft edges contrasting with hard ones, and some surprising color notes keep this painting intriguing.

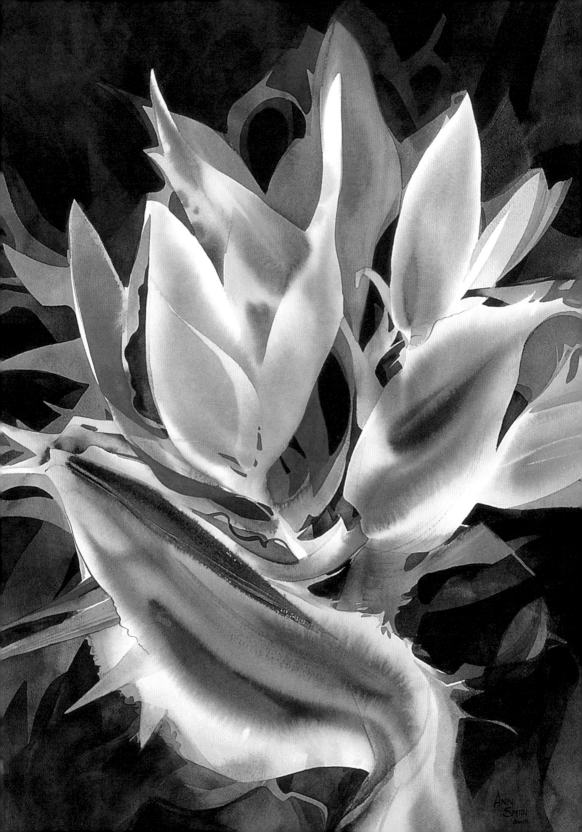

" The real beauty of painting flowers and plants is that they offer an almost limitless variation of color, shape, and texture; you are quite literally spoiled for choice, and will never be short of a challenge. A humble roadside poppy can be every bit as inspiring as an exotic orchid from a specialized nursery.

Tracy Hall
Learning through detailed sketching

BUILDING UP A PICTURE

For me, painting from a live specimen is the simplest and most satisfying option, whether cut stems in florist's foam or whole plants lifted from the garden and popped in a pot—they can easily be replanted afterward. It can be tempting to

CHERRY BLOSSOM *Studies for a painting include detailed drawings, some with added shading. Mix Payne's gray, alizarin crimson, and chrome yellow.*

PRELIMINARY SKETCHES
Here the leaf and flower structures are explored.

FIRST COLOR WASHES
The sketch below was used in the finished painting, shown above right, in progress.

ADDING THE COLOR
*Superimposed, very thin, layers of
rose madder are added,
allowing the white of the
paper to show through.*

FINE DETAILS *Veins
are added with a 000 brush, once the
buildup of color is complete and allowed to dry.*

PAINTING IN PROGRESS *In this study
some areas have been taken to a finished state,
while others show the progression from the
initial light washes, blocking in the subject,
through to the fine details added at the end.*

jump right in and start painting, but it is worth taking time to get to know the plant through sketching, since this is really the only way to begin to understand how it is all put together.

A simple line drawing, reducing all the elements to basic geometric shapes, helps me to see the specimen more clearly, before working up to more detailed studies of specific features. Armed with this background work, the final painting is all the easier. Added to this, I take plenty of photographs, and the photos and sketches together make an invaluable source of information when I come to paint the final piece, especially if this is months, or even years, later.

I begin a painting with a rough plan of the composition, lightly penciled in and showing the placement of each stem or leaf. I then make a detailed drawing, again lightly penciled in since many of these lines will be erased as the work progresses. I take my time on this stage and will rework areas as needed. Next, I lay in a thin shading mix, made up of Payne's gray, alizarin crimson, and chrome yellow, for the shadows, which will be deepened as required later. Then I apply the colors in a series of thin washes, building up gradually, working sometimes wet into wet, sometimes drybrushing, lifting out areas with a damp tissue or a moistened brush tip and strengthening other areas with more color. Once this stage is complete and dry, I add the final details, including fine hairs and veins. **"**

*Favorite
colors*

PAYNE'S GRAY
BLUE ULTRAMARINE
ALIZARIN CRIMSON
WINSOR RED
CHROME YELLOW
YELLOW OCHER
BURNT UMBER
HOOKER'S GREEN
CHINESE WHITE

PENCILS AND PAINT
The artist has used graphite and
 colored pencils as well as watercolor
 in her flower studies.

Graphite A pure line
 drawing, eliminating
 all detail, helps to
 sort out the
 shapes and
 allows you to see
 clearly the
 structure and
 petal arrangement
 of the flower head.

Colored pencils These are
 used for a different
 approach in the leaf study
 of the poppy.

Finest detail The tiny individual
flowers of the northern marsh
orchid are patterned in the richest
 colors. Here the painting of these
 intricate details is almost
complete. Color has been added
 painstakingly wet into wet and
then wet on dry.

Color studies
Tonal washes are
 added (left), and
 in color, using
 watercolor (above),
 and colored
 pencils
 (right).

Foxgloves *Detailed study sketches show the veins and fine hairs.*

Exploration studies *These studies look at various characteristics of the foxglove: the overall spire structure with leaf and bud positions; the color progression of the flower heads, lighter at the top; and a simple line drawing, developed in a colored pencil study, of the pattern inside the flower heads.*

Observation *Note the mottling on the leaves and the deep pink veins, as well as how the leaves join the main stem.*

Tonal studies *These are explored in pencil (left) and in colored pencil (right); the leaf of the yellow foxglove.*

A pansy bud This study (below) focuses on the complex meeting of bud and stem.

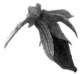

Different mediums The same poppy is explored in watercolor and pencil, (above, and above right).

Pansy studies The artist explores the form and color of pansy flowers, stems, and leaves, (center page). Pencil sketches establish tonal values and the pattern of the veins prior to painting. Transparent tonal washes give a color base for the fragile petals, fine detail line work is then added using the wet on dry technique.

Ravishing outline In the center of this poppy, with its unusual petal shapes, lies the emerging seedhead, studied in detail below.

Exploring shadows
The edges of the petals
are created by the
shadows around them.

Anemone With the flower head
complete, the leaves are blocked in,
ready for detail to be added.

Transparent color The buildup
of washes needed to capture the
color of the anemone is
explored in these petals.

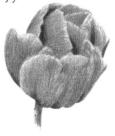

Anemones in progress
With the tonal washes
applied, the flower
head (below right) is
ready for the first layers of
color. This one (right),
with the underlying washes
complete and dry, is in the
process of having fine veins added
with a 000 sable brush.

Focus on the flower center
Chinese white, mixed as
required with alizarin
crimson and Payne's gray,
is used to paint fine hairs,
(below; and below
center right).

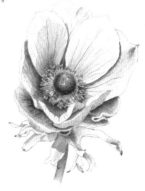

Index

Page numbers in *italics* refer to captions

A

abstracted paintings 130, 133, 134
agapanthus 124
allium *105*
amaryllis *120*, 124
Andrews, Carole 11, 110–119
anemone 59, 141
annotations *see* notes, written
arnica 59

B

background 23, 44, 78–79, 83, 99, 115
berries 33, 47, 88
bird-of-paradise 38–39, 134
Blockley, Ann 11, 25, 78–85
bloodroot 68
bluebonnet *31*
blues 91, 95, 102
botanical studies 92, 100–103, 104, 106–109
bottle plant 108
brushes 11–12
buds 92, 102, *111*, 140
butterfly weed 66

C

cherry blossom *136*
clematis 96–97
color: to build up 34, 76, 114
 change 32
 coding 55
 complementary 35, 42, 60, 107
 harmony 45
 leaf 26–7, 32, 56, *63*, 64, 72, 92, 118
 linking 49, 51, 53
 mixing 24–25, 27, 113
 notes 17
 options 97
 palette 24
 plotting 50
 reference 90
 reflected 27, 117, 118
 shadow 25, 109, 123
 testing 108, 113
 unity 47
 values 74
common ragwort 94
composition 22–23, 45, 50–53, 57, 88, 105, 110–111, 137
 field guide 109
contours *120*, 121
contrast 32, 65, 80
cornflower 100–103
Cox, Freda 86–91
cropping 22–23
cryptanthus 106
cup-plant 61
cyclamen *70*, 114–115

D

daffodil 112–113, 116–119
dandelion clock 84
Donnelly, Marlene Hill 14, 54–61
drybrushing 137

E

Ecuadorian plants 32–33
Edey, Iris 9, 12, 16, 70–77
edges 78, 82, 109, 115, 126
 to define 34
 found 114, 122
 lost and found 81
 to soften 116, 117
editing 20–21

F

flower kit 13
focus/focal point 81, 110
form(s): to build 32
 to create 42
 to describe 44
 round 33, 90
 to suggest 133
foxgloves 139

G

geranium 71
gladiolus 123
goat's beard 92
gouache 84, 101
greens 26–27, 37, 92, 101, 108

H

Hall, Tracy 136–141
Harper, Lizzie 92–103
hedge bindweed 69
hellebore 80–81
helleborine 42
hepatica 58
highlights 36, 39, 101, 107, 112, 114, 117
Himes, Sharon 62–69
honeysuckle 69, 98, *111*
horse chestnut 108–109
hyssop skullcap 67

I

Icelandic flowers *105*, 106
Indian paintbrush 58
indigobush 105
ink 57, 59
 Dr. Martin's watercolor 97, 101
 and paint 100, 102
ipomoeia 55
iris: bud 111

California native 129
Pacific Coast *120*
wild 63
Irish flowers 88

J

Japanese butterbur 93

L

lady's smock *92*
lavenders 72–73
leaves 35, 56, 64, 91, 114, 115
 color 26–27, 32, 56, *63*, 64, 72, 92, 118
 structure 19, 94
 texture 36, 92
lesser periwinkle 95
lifting off/out 13, 80, 137
light 21, 59, 60
lily 99
 stargazer 82–83
 Turk's cap 58, *62*
line and wash 17
line work 120–121, 126

M

Macnamara, Peggy 9, 13, 30–39
magnification 61
magnolia *31*
marsh marigold 57
 mountain 60
masking fluid/tape 13, 80
may apple *54*
morel *54*

N

negative shapes/spaces 23, 42, 49, 50, 68, 108, 126, 133
neutral tints 68, 69, 133
notes: color 17
 written 17, 54–55, 92, 103

O

orchid 33, 34–35, 107, 126–127

bee 45
cymbidium 126
lady 44
northern marsh 138

P

Paige, Jane Leycester 9, 40–53
painting kit 11–13, 41
pansy *130*, 140
paper 9
pen and ink 12, 16, 70–71
pencil(s) 12–13, 16, 138, 139, 140
 colored 13, 16–17, 138, 139
 too much 112
perspective 47, 90, 99
Petrides, Olivia 104–109
philodendron *104*
photographs 137
pinks 115
pitcher plant *105*, 106
pollen 99
poppy 138, 139
proteus plant 133
pulsatilla 49
pussy willow *105*

R

red catstail 31
Robertson, Sally 120–129
rose *111*

S

salsify 90
sand dune plants 46–47
sanguinaria 58
sea buckthorn 47
sea holly 46
seedheads 88, 90
senecio 59
shadows 25, 26, 27, 60, 96, 97, 109, 112, 116–117, 122, 123, 141
simplifying 21, 52, *62*, 72, 100, 133
sketchbooks 8–9
 seasonal 62–63

sketching 6
 botanical 15, *16*
 gestural 14, 38, 55
 interpretive 78
 media 16–17
 pencil 16
 styles 14–15
 watercolor 15, 17
skunk cabbage 55
Smith, Ann 130–135
spattering 81, 82
speedwell 92
spiderwort 59
stems 74, 75, 90
 color 72, 124
structure: to build 51
 flower 18–19, 67, 96, 100, *105*
 leaf 19
subject, to choose 20

T

texture 32, 36, 47, 49, 66, 78–79, 84
thistle: cabbage 91
 carline 47
thyme 92
tonal range 21
tonal studies 138
tonal washes 138, 140, 141
tone, to build up 112
traced sketches 77
tragopogon *40*
trillium 58, 61, 69
trumpet vine 87
tulip *110*

U

viewfinder 22
viewpoint 20
violet 64–65
 dogtooth *40*
Virginia bluebell 61
visual pathways 22

W

washes 26, 27, 37, 38–39
 background 53, 80

repeated 52
shadow 42, 119
variegated 79, 80
waterbrush 13
watercolor:
characteristics 25
 paints 10–11, 121
 sketches 17
 transparent 70
wet in damp technique 33
wet into wet technique 36, 50, 110, 114, 115, 121, 127, 128, 137, 138
wet on dry technique 138
white flowers 58, 68–69, 80, 122–123, 124
whites 33
willowherb 56

Y

yellows 112, 116–119

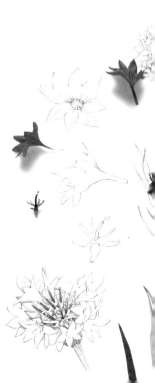

Acknowledgments

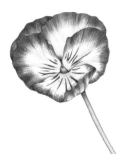

The author would like to thank the thirteen artists whose work appears here. Their talent and generosity of spirit made this book a pleasure to work on. Thanks also to the team at Quarto.

Quarto would like to thank all the artists who kindly allowed us to reproduce their work in this book and the following individuals who took part in the step-by-step demonstrations: Jane Leycester Paige, Lizzie Harper, and Carole Andrews.

Credits

We would also like to acknowledge the following illustrations reproduced in this book:

Key: l left, r right, c center, t top, b bottom

1c Lizzie Harper; 4bl Freda Cox, 4c Peggy Macnamara; 4c l to r Peggy Macnamara, Jane Leycester Paige, Marlene Hill Donnelly, Sharon Himes, Iris Edey, Ann Blockley, Freda Cox, Lizzie Harper, Olivia Petrides, Carole Andrews, Sally Robertson, Ann Smith, Tracy Hall; 6l Sally Robertson; 7t Lizzie Harper, 7r Jane Leycester Paige; 8bl Peggy Macnamara, 8c Marlene Donnelly; 9bl Iris Edey, 9tr Jane Leycester Paige; 12c Iris Edey; 14t Lizzie Harper, 14c, 14b Iris Edey; 15b Sue Kemp; 16t Lizzie Harper, 16b Jane Leycester Paige; 17 Lizzie Harper; 18t, bc Adelene Fletcher, 18bl, br Elisabeth Harden; 19, 20, and 21 Adelene Fletcher; 22b Jane Leycester Paige; 23t Adelene Fletcher; 26 Adelene Fletcher; 27t Jane Leycester Paige; 27b Adelene Fletcher; 142t Jane Leycester Paige; 143b Lizzie Harper; 144t Lizzie Harper.

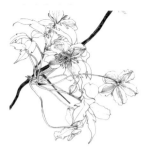

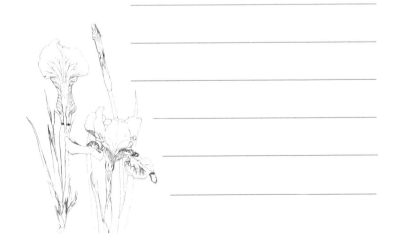